CHARLES M. RUSSELL

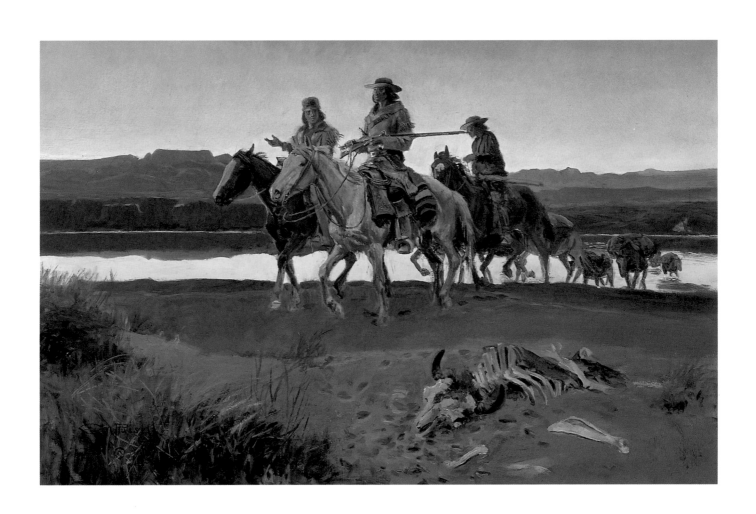

Charles M. Russell

PETER H. HASSRICK

University of Oklahoma Press
Norman

To my father, Royal B. Hassrick,
who, like Russell, knew and loved the West.

Library of Congress Cataloging-in-Publication Data

Hassrick, Peter H.
 Charles M. Russell / Peter H. Hassrick.
 p. cm.
 Originally published : New York : Abrams ; Washington, D.C. :
National Museum of American Art, Smithsonian Institution, 1989 in
series: Library of American Art.
 Includes index.
 ISBN 0–8061–3142–X (pbk. : alk. paper)
 1. Russell, Charles M. (Charles Marion), 1864–1926. 2.
Artists—United States—Biography. 3. West (U.S.) in art. 4.
Indians of North America—Pictorial works. I. Russell, Charles M.
(Charles Marion), 1864-1926. II. Title.
N6537.R88 H37 1999
709'.2—ddc21
[b] 98–44419

Frontispiece: *Carson's Men*, p. 110.

Text copyright © 1989 Peter H. Hassrick
Illustrations © 1989 by Harry N. Abrams, Inc.

Oklahoma Paperbacks edition published in 1999 by the University of
Oklahoma Press, Norman, Publishing Division of the University, by
arrangement with Harry N. Abrams, Inc., 100 Fifth Avenue, New York,
New York 10011. First published in 1989 by Harry N. Abrams, Inc.
Printed and bound in Japan. First printing of the University of
Oklahoma Press edition, 1999.

 1 2 3 4 5 6 7 8 9 10

Contents

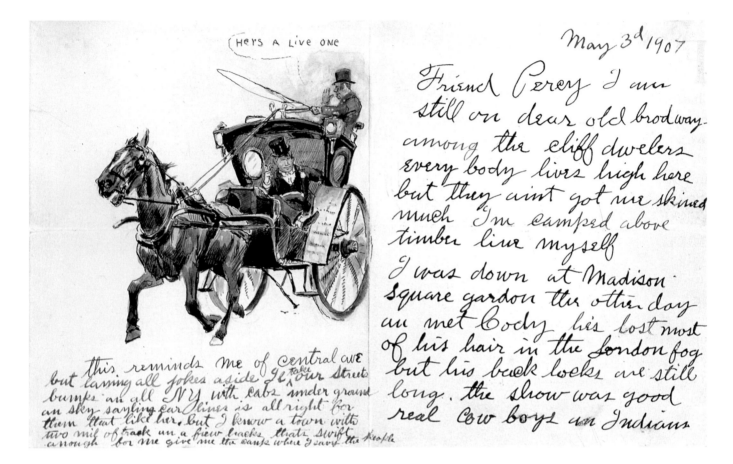

He's a Live One

Preface

FEW AMERICAN ARTISTS HAVE ENJOYED the popular acclaim and affection lavished on a seemingly modest western painter and sculptor named Charles M. Russell. Known as "the Cowboy Artist," Russell came to symbolize in his creative production the virtues of the frontier myth. He became not only the favorite son of his home state of Montana but the personification of the West itself. What he produced affirmed in the public mind the veracity of the American dream. Through his skill as a man of letters and the plastic arts, he expanded a set of regional themes into a national symbol. So engaging were his images, so appealing the iconography he explored, that he has entranced generations with the myth he set out to interpret and preserve.

Russell's observers have long boasted that his only lessons were those of nature. No atelier trained his brush to mix color; no master informed his eye in matters of composition. His was an innocent and self-born genius inspired of the heart and driven by a consuming fascination with human nature. His was a perception tinted only by a compelling aspiration to understand human history and to interpret its worth for others. Well, all of that is true to some degree, although, in an effort to lionize Russell over the years, the dimension of these considerations has been largely exaggerated.

Russell, as a man and an artist, saw tremendous value in the lessons of history and man's place in the scheme of things. He viewed himself as an ordinary man just somehow blessed with extraordinary abilities to communicate. Yet he cherished, far more than his skills, his place as a peer among common men. Friendships provided his fundamental raison d'être, and he frequently caricatured himself among his associates as if to say that this modest fabric of ordinary mortals was the basic common denominator in the human equation.

In the late nineteenth and early twentieth centuries, there were many visionaries—men and women who saw their own times as relevant only in the context of what the future promised. Charles Russell was not among those ranks. In 1907 he saw Buffalo Bill (William F. Cody) in New York's Madison Square Garden. Cody had set about preserving the frontier through dramatic re-creations in his Wild West exhibitions. Yet even more than a romanticist, Cody was a visionary, speculating on the importance of the West for the future of America. Virtues and values inherently manifest in the frontier experience could be applied to contemporary or impending events. Thus his Wild West supported the causes of both the Spanish-American War and World War I. Russell, however, wanted little to do with the present and nothing to do with the future. He chose to celebrate and romanticize only the traditions of the old West as he had known it. There was great significance in the task, and he needed no younger or future generation to confirm its relevance. For Russell the most evil of notions was prog-

He's a Live One

1907. Pen and ink with watercolor on paper
Courtesy of the Buffalo Bill Historical Center
Cody, Wyoming

After 1903, Russell visited New York often, and he enjoyed teasing his friends back in Great Falls with whimsical allusions to social transformations he might be undergoing.

ress, while for Cody progress paralleled hope itself. Cody welcomed the railroads, motored hither and yon in an automobile, and promoted irrigation projects that assured agricultural stability in the arid West. Russell cursed these things soundly and grumbled at all vestiges of civilization. He would not own a car, he despised the farmer, and he shuddered at the impact of the railroad. He was like the clock in one of his favorite drinking emporiums, the Mint Bar of Great Falls, Montana. The clock ran backward, so that one had to look into the mirror hanging behind the bar to tell what time it was. So it was for Russell. All that was relevant was seen over his shoulder (or through the mirror of history) in the past; what lay ahead was merely a reflection of that which had gone before.

A man of such convictions—a man who represented in his life, art, and philosophy the essence of history and its appeal—has obviously enjoyed a considerable following. So popular were his images of western life that he literally had to defend himself from the myth that had been created about him. He unraveled his first autobiographical account in 1903 and updated it periodically until his demise twenty-three years later. Since then many biographical efforts, beginning with a two-hundred-page treatment commissioned by his widow, Nancy, have been written, and most of them published. Thus the details of Russell's life need not be repeated, and it will be the intention of this volume to touch on those details only lightly. Instead, attention is focused on interpretation of the man and his art.

Such insights are not gained without considerable credit to others who have been observers of Russell over the years. Paramount among those to whom debt is acknowledged here are the late Frederic G. Renner and his spouse and protégée, Ginger. The extraordinary depth of information about Russell which these two possessed, and which Ginger was willing to share, provides the heart of this study. I am also indebted to Dale and Joanne Stauffer for their insights into Russell's personal life and character, especially Nancy's role in molding the artist. Brian Dippie, with his many insightful discussions of Russell and his art, has laid much of the groundwork for the observations in this volume. His encouragement and counsel have been greatly appreciated. David Wagner at the Colorado Springs Fine Art Center and Ray Steele at the C. M. Russell Museum opened their considerable research resources to me and provided able staff assistance in the persons of Jon Batkin and Janet Postler respectively. My thanks go to Lincoln Spiess and Lyle Woodcock of Saint Louis and to Michael Shapiro and the research staff of The Saint Louis Art Museum for helping to reconstruct an idea of Russell's associations with his hometown. As usual, the Amon Carter Museum and its staff have provided valuable assistance. Special thanks are due to Nancy Wynne and Rick Stewart. The Western History Department of the Denver Public Library revealed some sources heretofore unknown to me. And, finally, I extend warm thanks to my friends Bill and Bud Mackay, Sam and Elaine Rosenthal, and the many private collectors and museums who have consented to have their works reproduced here.

PETER H. HASSRICK

I Savvy These Folks

1907. Pen and ink with watercolor on paper,
7½ x 12″
The Thomas Gilcrease Institute
of American History and Art
Tulsa, Oklahoma

Russell felt at home among common men of the West. He had no hunger for society's recognition or upward mobility—just real people and real friends mattered.

8

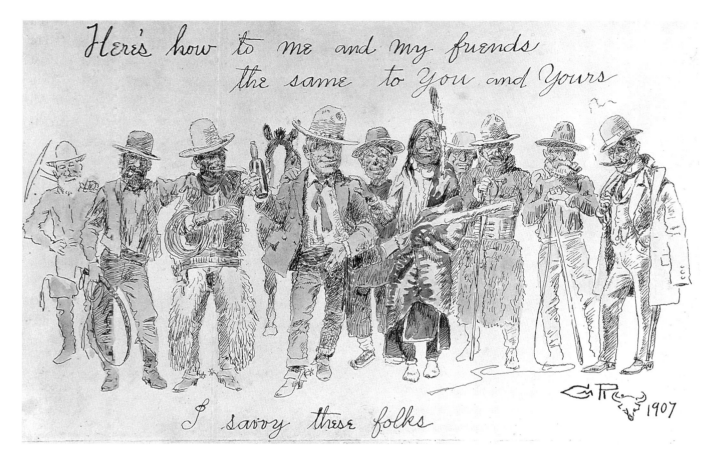

I Savvy These Folks

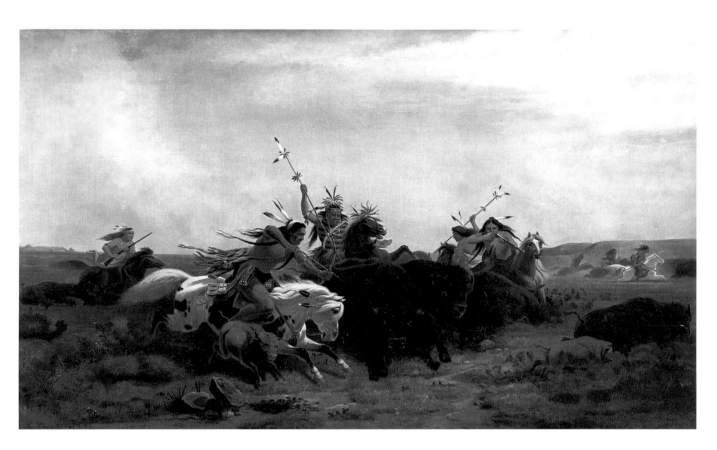

KARL WIMAR
The Buffalo Hunt

I. The Invitation

The herding and breeding of cattle...is...the primitive scriptural occupation, the grand, independent, health-giving, out-of-door existence, the praises of which have been sung through all the ages. To how many a pale, thin, hard-working city dweller does the thought of "the cattle on a thousand hills," the rare dry air of the elevated plateaus, and the continuing and ennobling sight of the mighty mountains bring strangely vivid emotions and longings?

Harper's Monthly (1879)

C HARLES RUSSELL WAS BORN of a place and time that naturally drew his destiny westward. His biographers recount that his father, Charles Silas, was a college graduate and that Charles himself, as the consequence of poor academic achievement as a youth, spent part of a year at a military academy in New Jersey. But he began his life in Saint Louis in 1864, and his youthful attentions were down a frontier path rather than toward any road to civilization.

For a boy in Saint Louis, such a focus was not especially extraordinary. Russell's father claimed lineage with the celebrated Bent family, explorers and traders who played such a vital role in early western exploration. As Russell grew into boyhood directly following the Civil War, the nation itself sought distraction from the years of tragic conflict and regarded the West as something of a spiritual as well as a physical panacea. There along the upper reaches of the Missouri River valley, among the crested shadows of the Rocky Mountains, and across the seemingly endless prairies lay a promise for America's future that genuinely lured grown men as well as boys.

As Russell grew up, he recognized within himself a dual force. From his mother and sisters he had been endowed with skill and interest in art that hinted at promise if not precociousness. From his father he absorbed a yearning for some meaningful physical association with the burgeoning frontier, which he could see to the west from the bedroom windows of his home in Oak Hill, one of Saint Louis's suburbs. As he drew scenes of western life in the margins of his schoolbooks and dreamed of adventure beyond the limits of his urban environs, he must have wondered about ways to realize his aspirations. Yet right there in his hometown lay all the answers, all the previous lessons an aspirant could have

KARL WIMAR
The Buffalo Hunt

1861. Oil on canvas, 36 x 61"
The Thomas Gilcrease Institute
of American History and Art
Tulsa, Oklahoma

This Saint Louis artist glorified the Indian by portraying his exploits as a hunter and horseman. Russell would glean from these pictures methods for imparting the same message a generation later.

11

wanted. For Saint Louis, as the stepping-stone to the frontier, had for almost two generations before Russell attracted artists who sought to ally adventure with art and focus on themes recognized for their unique American spirit—themes of frontier life.

Saint Louis began to serve as an artistic hub in the early 1830s when Peter Rindisbacher arrived there with stirring views of Indian life. Rindisbacher settled in the city briefly, attracted by its society folk, whom he saw as potential customers for portrait commissions, and by its proximity to the frontier. George Catlin and Karl Bodmer passed through the city on their way west to capture the likeness of Indian peoples and their way of life. Many of Russell's childhood sketches demonstrate the impression their images made on him.

In the 1840s there emerged in Saint Louis a corps of artists who dedicated themselves to portraying western subjects. George Caleb Bingham was the most celebrated of the group. The clear, classical simplicity of his paintings imbued everyday genre scenes with a poetic charm and quiet dignity. But there was a contemporary of Bingham's whose life for a short period paralleled that of Russell. His name was Charles Deas, and he moved to Saint Louis in about 1840. Unlike Bingham, Deas was not content to mix his genre work with commissioned portraits of Saint Louis society. Instead, he sought real experience west of the city, searching for personal identification with the Indians and trappers who roamed the wilderness beyond the Missouri. At first he made modest forays beyond the city to Fort Crawford and Painted Rock to paint Indians; then in 1844 he ventured farther afield. Donning the attire of a mountain man, he signed on with an army expedition to the Pawnee villages near Fort Leavenworth on the Missouri River. As a result of this adventure, he was given the sobriquet "Rocky Mountains." He adapted his personality to function properly on the frontier. Costume and language, humor and demeanor were all brought consciously into play to ally him physically and psychologically with the trappers and Indians who were his frontier subjects.

As a result of his 1844 trip west, Deas produced one of the most significant frontier images in the history of American art. At the Art-Union in New York that year he exhibited his finest western picture, *Long Jakes*. The subject of the painting was iconic—a symbol of dominance, independence, isolation, and pride. Long Jakes was also the artist's alter ego. Deas identified with the mountain man, although a hint of the artist's urbanity could be sensed in the countenance of this equestrian hero of the wilderness.

With the national acclaim for *Long Jakes*, Deas helped to establish the mountain man as one of the fundamental figures of American iconography. And in his own life-style and habits, Deas directly associated himself, as an artist, with the symbol he was helping to fashion. Charles Russell would fit this pattern perfectly a generation later. His efforts to perpetuate and preserve the image of the cowboy—the replacement for the mountain man in American iconography—and to live as one among them would mirror Deas's experience and aspirations.

Deas and a group of mid-nineteenth-century writers and genre and histori-

CHARLES DEAS
Long Jakes

1844. Oil on canvas, 30 x 25"
Private collection

Deas's mountain man was the precursor of the cowboy in America's search for the perfect symbol of the free, untethered man. It was an image born of Jeffersonian democracy that became a celebrated national icon.

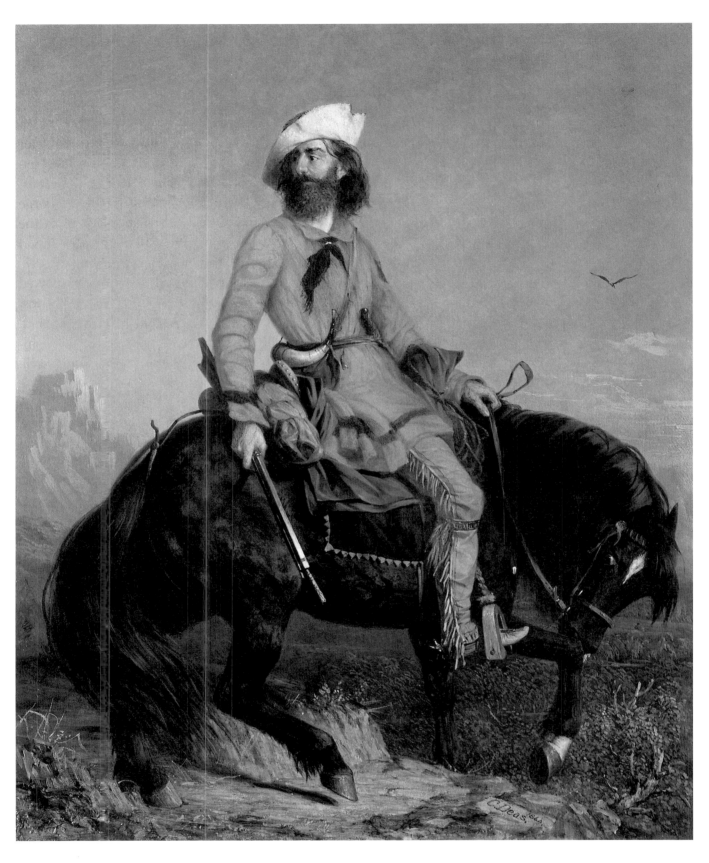

CHARLES DEAS
Long Jakes

cal painters were responsible for creating the western myth that Russell would later sustain. That myth centered on the concept of an untamed expanse of nature populated by rugged individuals who defied the bridling constraints of the emerging Industrial Revolution. It was a myth that found strong support and praise in the East, as well as along the fringes of the frontier, informing the collective conscience of the whole nation.

Dedicated to supplementing that myth with his considerable artistic talents and personal adventures in the West was another Saint Louis painter, Karl Wimar. Shortly after Deas stopped painting, in the late 1840s, Wimar took his place as an interpreter of western life. Strongly theatrical and moralistic in his approach to frontier subjects, Wimar passed along the academic conventions he had learned as an art student in Düsseldorf, Germany. While Russell was probably familiar with *Long Jakes* (it was copied in engraved forms and circulated widely as a popular print), certainly he knew and was directly influenced by Wimar.

Wimar is known to have made two extended trips up the Missouri River in the late 1850s. On the second of these odysseys he traveled as far as Fort Benton, in the heart of the country that Russell would eventually call his home state of Montana. The themes of the resulting works produced by Wimar, the buffalo hunt in particular, excited Russell's imagination. Wimar's paintings were held in private and public collections where Russell would have had ready access to them. Wimar's favorite subjects were Indians, and he portrayed them with romance and drama.

The Indians of the Far West were, of course, threatened by civilization, just as Long Jakes and his compatriots were. Together these two groups became romantic heroes in the national imagination. And like all romantic heroes, they were doomed. By the time Russell was born, the plot and the myth of this western saga were firmly established. His role thus became one of adaptation and continuity rather than invention. By the time Russell came on the scene, there were firm attitudes in place not only about the destructive interference of industrial civilization but even the oppressive intrusion of agriculture. The nineteenth-century American historian Francis Parkman, for example, lamented the domesticating influence of the yeoman surge west. The golden days of 1846, which he described in *The Oregon Trail*, were quickly obliterated by the spreading agricultural frontier. The tensions, both social and mythical, established in such literature also informed young Russell, who chose one fundamental way of dealing with it. He immersed himself in the myth and dreamed of a day when he might go west himself, a time when he might escape into adventure.

As a boy being raised in an upper-class Saint Louis home, Russell found no support for his dream of physical escape. His family envisioned other roles for him than a part in western folklore—education and a business career, in that order. Thus Russell's focus turned to history, particularly popular literature of the day, which could embellish a boy's imagination and provide a rich store of vicarious experiences.

Among the literature to explore would have been James Fenimore Cooper's tales of Leatherstocking. Essential to any youthful understanding of the frontier, they shared lessons fundamental to the edification of wonder-struck boys like Russell. Among those lessons was a set of appositives that would be abundantly clear even to a boy—that individual freedom does not flourish within the confinements of community and that the equality of men in nature countered the social stratifications imposed by civilization. As expanded by the dime novels of Russell's day, these themes guided his view of the world and directed his place within it. He wished somehow to be one with the natural man, his heroic ideal, and to fashion his persona around the potencies of the western myth, which he saw as a vital and real way of life.

Russell's dream of the West was a journey into nature, and for this he was uncommonly suited. The family traditions of daring provided a model. Not only could he look back at the example of the Bent brothers but his uncle, William Fulkerson, had been a Pony Express rider. He was also responsible for teaching young Charles to ride and for inspiring the boy's love of horses.

Beyond sheer daring, Russell possessed the social diffidence to separate himself easily from civilization. His father appears to have been something of a loner, a trait that may have carried over to his son, allowing him to be content as a night wrangler for eleven years.

Most importantly, Russell had an exceptional skill that became apparent during his youth. He was able to render what he saw and imagined, and his enthusiasm and energy were, in that regard, unflagging. His maternal grandfather, Edward Meade, was a well-regarded Saint Louis silversmith, and Russell's mother, Mary, was recognized as an artist. Other members of the family are said to have had exceptional artistic talent, including two of his brothers, Wolfert and Ed, his sister Sue, and an aunt by the same name. Charles's talents were recognized at home and encouraged by both parents. In 1876 and the following year Russell submitted work to the Saint Louis County Fair, each time winning a blue ribbon. There is evidence that his parents may have attempted to enroll him in art classes or special tutorials at this time. And there is speculation that he briefly attended art classes at either the Washington University School of Fine Arts or the Saint Louis Art School, but no records survive to substantiate the claims. When Russell eventually set off for the West of his dreams, shortly before his sixteenth birthday in 1880, it appears that he already possessed an abiding will to become an artist and to explore those talents more fully.

Thus for the invitation to go west that lay at every American's feet in the 1880s, Russell was especially well equipped to respond in the affirmative. He harbored contempt for the shortcomings of society and civilization; he understood that the symbolism of the western myth could have direct application to life, including his own; and he possessed something in the way of skill with which to interpret and preserve that myth. Saint Louis and its traditions had helped him to identify with the West. And, most significantly, there was a place that could accept Russell's dream and welcome his wanderlust. That place was Montana.

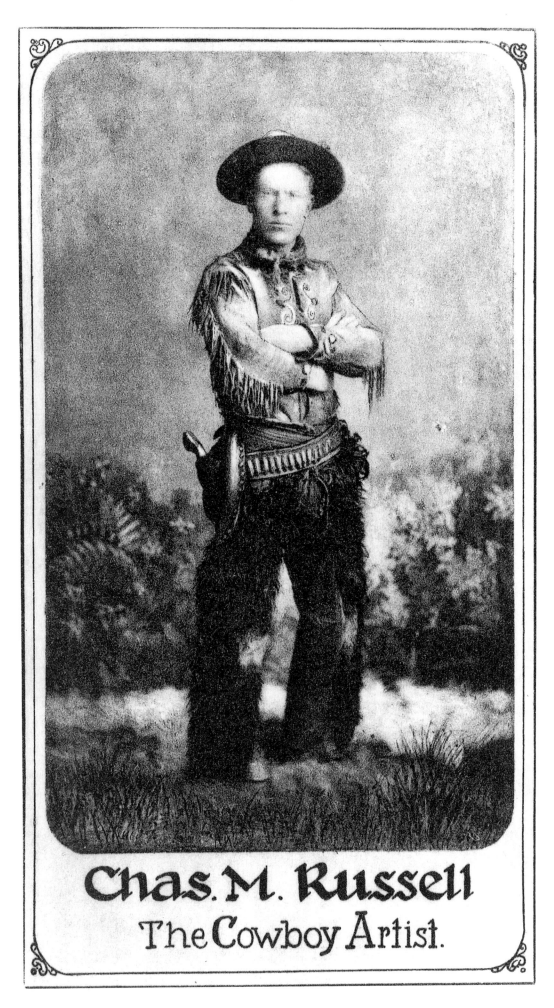

Chas. M. Russell
The Cowboy Artist.

Kid Russell

II. The Last Song

O you youths, western youths,
So impatient, full of action, full of
manly pride and friendship,
Plain I see you, western youths, see
you tramping with the foremost,
Pioneers! O pioneers!

Walt Whitman
Pioneers! O Pioneers! (1865)

RUSSELL ARRIVED IN MONTANA in March of 1880, just prior to his six-teenth birthday. Emerging from a stagecoach onto the streets of Helena, he stepped indelibly into the history of the West. He had come to test his character and to fulfil his destiny, as he had fashioned it for himself from the pages of dime novels. His parents, out of frustration with the boy's truancy and academic failures, had arranged the trip, hoping that a summer would set Charlie straight. However, he knew, when he first planted his foot on Montana soil, that his dream had come true—a dream that home ties, no matter how strong, could not shatter.

Russell's arrival in Montana coincided with the beginning of the great western cattle boom. The following year writers such as James Brisbin, in his *Beef Bonanza, or How to Get Rich on the Plains*, would proclaim the vast riches in store for those who would venture to invest in land and cattle. Newspapers from Laramie to Helena espoused the same message. Russell had not gone west to seek financial rewards. He sported no bankroll for speculation in real estate or beef, and harbored no vision of owning his own spread. But he did have his manhood to search for—he was out to prove his mettle—and there could be no better place than Montana for that enterprise. Russell found himself at exactly the right place and time to explore the full expression of the western cult, the cult of masculinity and the brotherhood of cowboys, its heroes.

Throwing a new saddle across the back of a fresh mount in Helena did not a cowboy make, however. Russell was forced by circumstance to undergo an apprenticeship of sorts before being admitted to the cowpuncher fraternity. The

UNKNOWN PHOTOGRAPHER
Kid Russell

c. 1883
Courtesy of the Buffalo Bill Historical Center
Cody, Wyoming

Russell went to Montana bent on fitting into the scene, discovering his place in the cattle kingdom, and proving his manhood. These aspirations reveal themselves plainly in this portrait photograph of him.

17

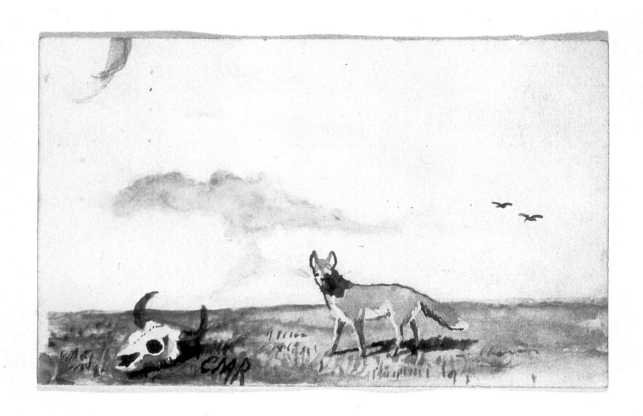

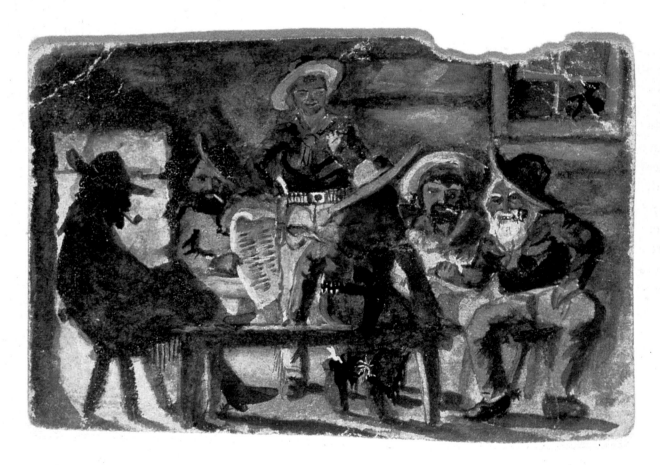

The Lone Wolf
Telling some Windies

man under whose wing Russell's father had placed Charlie was a young sheep rancher named Wallis (Pike) Miller. He figures only modestly in Russell's biographies primarily because of Charlie's distaste for the occupation of sheep tender. Miller was one of many men from Saint Louis who struck out for Montana with the hope of riches, and he was ready to make a stake in the Judith Basin, a relatively unsettled area of west central Montana. Charlie rode along for the experience, but once things got settled into a routine, it quickly became apparent that Miller's business and Charlie's dreams were distinctly incompatible. He soon left Miller for more romantic escapades.

What Charlie found over the next hill was the full embodiment of his epic expectations—a trapper and hunter by the name of Jake Hoover. Here was a mountain man whose proximity to the cowboy was tangential. He was charged with the job of hunting for meat to feed the ranchers and miners in the area—a prosaic and primitive vocation, it would first seem, yet an independent way of life, close to nature, and certainly parallel to Cooper's Leatherstocking. Hoover personified the dime-novel character familiar to Russell and his contemporaries. Here, as historian Henry Nash Smith has described him, was the "benevolent hunter without a fixed place of abode, advanced in age, celibate, and of unequaled prowess in trailing, marksmanship, and Indian fighting." Hoover emerged as if fresh from the pages of Erastus Beadle's dime novels, of which about forty were produced between 1860 and 1893.

Deadwood Dick, made famous by author Edward L. Wheeler, embodied these traits, except that he was young and romantically available. He was a testament to the self-made man, lacking in formal education and untainted by inherited wealth, who, as cultural historian Merle Curti has written, "confirmed Americans in the traditional belief that obstacles were to be overcome by the courageous, virile, and determined stand of the individual as an individual." Thus Russell found his persona cast. He could be the youthful Deadwood Dick in tow with the elder woodsman, the Leatherstocking of a new generation. What more appealing circumstance could unfold than to escape the mundane drudgery of shepherding a flock for the prospect of slipping into the pages of American folklore and meshing harmoniously with its heroes? Charlie Russell chose an epic course in the simplest of all worlds—the Montana wilderness. He fondly remembered time spent with Hoover in the wilds in his written recollections:

> Shut off from the outside world, it was a hunter's paradise, bounded by walls of mountains and containing miles of grassy open spaces more green and beautiful than any man-made parks. These parks and the mountains behind them swarmed with deer, elk, mountain sheep, bear, besides beaver and other small fur-bearing animals. The creeks were alive with trout. Nature had surely done her best. No king of the old times could have claimed a more beautiful and bountiful domain.

Russell spent two years with Hoover learning the ways of frontier life and of woodcraft. He rode hard and lived freely, targeting no less a bounty than Buffalo Bill had done in the 1870s when he won his name in pursuit of game to nourish

The Lone Wolf

c. 1882–3. Watercolor, 2³⁄₁₆ x 3½"
Courtesy of Thomas B. Curtis and
Susan Ross Curtis, from the collection of
Nellie Miller Glasgow

Telling some Windies

c. 1882–3. Watercolor, 2½ x 3¾"
Courtesy of Thomas B. Curtis and
Susan Ross Curtis, from the collection of
Nellie Miller Glasgow

Even in Russell's very earliest western work he explored themes that would recur throughout his artistic career. The coyote is a lone character symbolizing the freedom of individual spirit found in its purest form out West. That unspoiled harmony with the wilds was shared within the camaraderie of small groups of men. Their singular experiences related in oral tradition, one to the other at the line camp or when "wintering," provided Russell with the store of anecdotes which he later compiled in his popular writings.

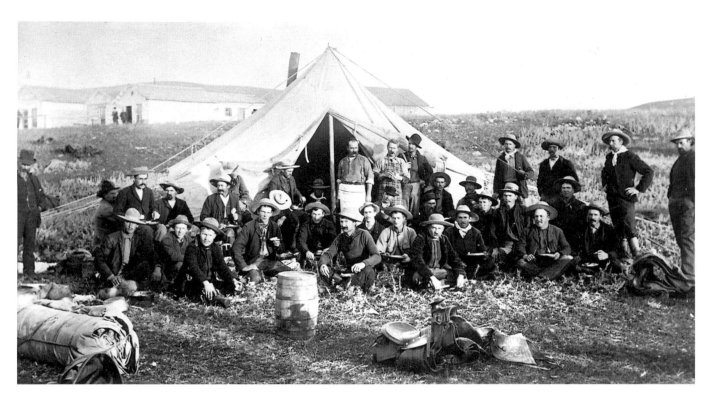

Judith Roundup at Utica

the railroad crews building the roads west. Hoover and Russell fed the miners and ranchers whose goals were no less tied to Manifest Destiny. Thus, despite expressing the will to serve nature by retreating to her heart and living among her chosen children, Russell was, in fact, serving civilization. A paradox was developing that would grow significantly stronger during the years ahead, providing a rationale for Russell's entire life and work as he strove to build defenses against it. For whenever he viewed his life experiences as natural and liberated, he would know in his heart that he had actually represented the vanguard of the very progress he despised.

Assuming that Russell recognized this paradox early in his western experience, while realizing that he had no wish to divert his course of life, he was left few choices. He selected the most reasonable course, which was to seek identification with the frontier as best he could and to exploit his innate artistic talents as a means of avoiding or moving beyond the paradox. He had no sooner stepped off the stagecoach in Helena than he was testing his skill at recording the scene, as well as living and experiencing it.

The earliest Montana remembrances of Charlie were of a boy known as "Kid Russell," who, along with being rough and ready, was known to carry art supplies in an old sock and who impressed associates and passersby with his abilities at painting and sculpture. The accounts of his artistry go back to virtually the first day he and Miller set foot in Montana. In Helena they encountered one of Miller's old acquaintances, Colonel Shirley Ashby, who invited the two to lunch. After the meal Miller told Ashby that Charlie possessed artistic aspirations and talent. When challenged to prove the assertion, Russell reputedly pulled a wad of wax from his pocket and fashioned a horse for his host. He repeated this artistic feat time and again for the ranchers he met during the next few years. And so his reputation grew—not as a hunter, a sheep man, or, in subsequent years, a cowboy, but as Kid Russell, who fit the physical image of a Montanan but who also could step out of the picture to make a picture of the life around him.

In 1882 Russell returned to Saint Louis to visit his family. He had earned enough money to pay his own way and proudly arrived home with an impressive array of tales and experiences. He had come home, of course, to show his family that he still cared for them and that he was faring well in the West. Within several weeks he was back in Montana, and this time he stepped from the railroad car in Billings into the world of the cowboy. Within a short time he found employment with some of the best outfits. He rode with the roundups and was ultimately one among a unique class of men.

Russell's job during the next eleven years was not that of a working cowboy but rather a night wrangler. This occupation did not carry quite the status of a cowboy, but he worked hard at what he did and always kept his job. It also allowed him to spend part of his waking hours observing the cattle business and exploring that world in paint. In 1917 he wrote to one of the old cowboys, Kid Price, remembering fondly the early pictorial records he had made of that life. "It's been some years since I laid on my bellie in the shade of a wagon, and built pic-

UNKNOWN PHOTOGRAPHER
Judith Roundup at Utica

1884
Courtesy of the C. M. Russell Museum
Great Falls, Montana

Russell, seated front row and third from the left, belonged to the Utica cow camp of 1884. The buildings, tents, and men behind him became the subjects for his early oil paintings.

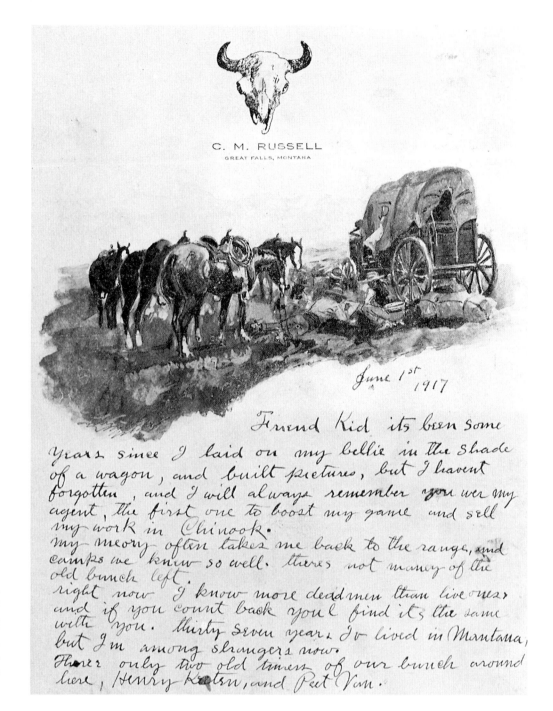

Letter to Friend Kid [Price]
(page 1 of 3)

1917. Pen, ink, and watercolor
Whereabouts unknown

Russell painted for the joy of creating and the entertainment of his fellow cowboys on the roundup. Here he paints in the shadow of a wagon, while a group of admirers look over his shoulder.

tures, but I haven't forgotten, and I will always remember you wer my agent, the first one to boost my game and sell my work in Chinook." (In this and all of Russell's letters, his idiosyncratic spelling has been retained.) What Russell produced were sprightly, if somewhat stiff, watercolors depicting cowboy life. These views of the Montana range, frozen and awkward yet spirited in rhythm and vitally perceptive of the excitement of equestrian supremacy, held for Russell and his admirers an immediacy that forgave all the shortcomings of technique. Russell's cowboys who work the herd in *Judith Basin Roundup* are evidence of a youthful celebration of real life. The brands are recorded as faithfully as the distant pro-

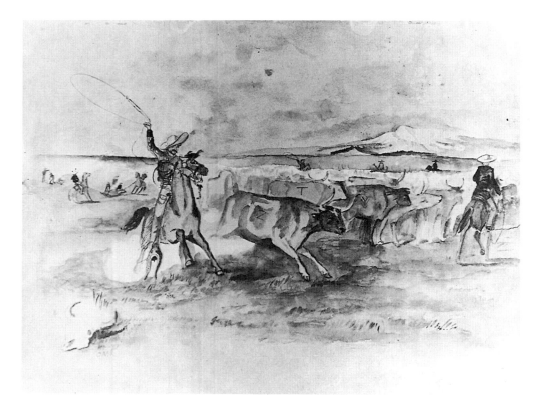

Judith Basin Roundup

c. 1882. Watercolor, 9¾ x 13¾"
Private collection

Russell was proud of his first wrangling job. His boss, John Cabler, was foreman of an outfit with a thousand head of cattle (Z and CT brands) and about forty saddle horses.

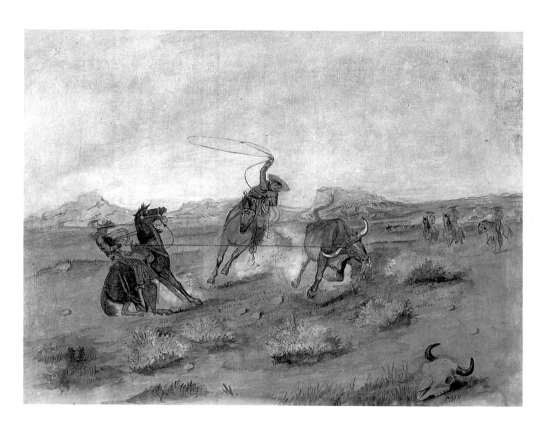

Roping the Renegade

c. 1883. Pencil, watercolor and gouache on paper, 12½ x 16⅝"
Courtesy Sid Richardson Collection of Western Art
Fort Worth, Texas

As early as 1883 Russell was exploring sophisticated compositions with difficult technical demands such as foreshortening of figures and horses in motion.

file of hills. Feats of horsemanship relate directly to Russell's search for manhood and his personal identification with the scene.

Yet even here, in this early pictorial record of roping Texas steers, Russell introduces without subtlety a vestige of romance. Already he understood and presented the West as an ephemeral thing, for prominent in the composition is a buffalo skull with the artist's initials beside it. By 1885 the vocation of the cowboy had already replaced, if not decimated, the previous plains culture and its subsistence unit, the bison. Historical imperative was already obvious to Russell, and he alluded to it without apology yet with quiet reverence. By 1885 the artist also knew that even the cowboy era was to be short-lived, that the range was teeming with beef and soon the cattle kingdom would succumb to nature or human greed and wither to little more than memory. Thus his first personal symbol, his first expression of identity beyond his name or initials, equated him with the very cultural influence and transformation that he ostensibly had resisted by moving west. He represented himself as a symbol of the inevitability of change and the conviction that yesterday's traditions transcend today's and that today's, by virtue of the moral superiority of the past over the future, would surpass those of tomorrow.

THE LAST SONG

Cowboy Camp during the Roundup

1887. Oil on canvas, 23½ x 47¼"
Amon Carter Museum
Fort Worth, Texas

By 1887 Utica, Montana, was home for Russell much of the time. His studio was set up in the back of the first white building on the right. Jim Shelton, his patron who ran the saloon up front, is seated on the porch.

He waited only a few months for proof that the cult of the open-range cowboy had a tenuous hold on life. The winter of 1886–87 dashed the hopes of hundreds of ranchers. The prairies had become overstocked, and in the quest for quick profits, few precautions had been taken for dealing with the whims of nature. When winter's rages reached their severest level, tens of thousands of Montana's cattle perished. Russell, who was wintering with hands from the OH Ranch, produced a summary statement of the aftermath of such neglect, a small watercolor, *Waiting for a Chinook*. So simple was his pictorial statement, so clear its message, that it seemed to possess a profundity well beyond its linear and chromatic naiveté. It was with this unpretentious yet visceral evaluation of reality that Russell won his first regional acclaim. The painting was sent to Louis Kaufman of Helena, who owned five thousand cattle then wintering on the OH Ranch, in answer to his request for information on how his herd was faring. So powerful was the diminutive watercolor that Russell's reply needed no verbal articulation. Either Kaufman or its next owner, Ben Roberts of Cascade, had the picture reproduced photographically and distributed widely. Thus Russell began to find recognition beyond his fireside companions at the roundups. Pressure was exerted on him to replicate the painting for others, but he resisted the tempta-

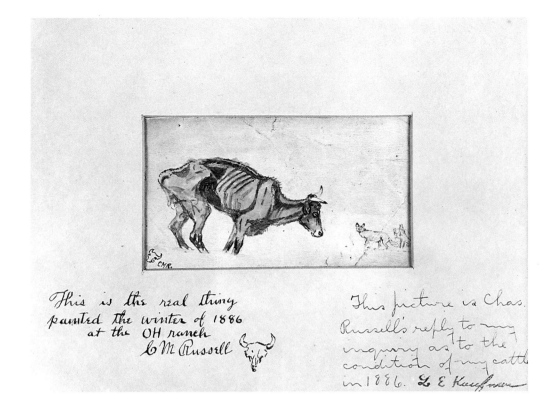

This is the real thing painted the winter of 1886 at the OH ranch CM Russell

This picture is Chas. Russell's reply to my inquiry as to the condition of my cattle in 1886. L E Kaufman

Waiting for a Chinook

1886. Watercolor, 3 x 4½″
Montana Stockgrowers Association. Courtesy of
the Montana Historical Society
Helena, Montana

Though tiny, the first version of this work was a powerful statement of pathos and finality. It is not surprising that the picture created a stir among cattlemen and brought Russell his first regional recognition.

Waiting for a Chinook
or *The Last of Five Thousand*

c. 1903. Watercolor, 20¼ x 20″
Courtesy of the Buffalo Bill Historical Center
Cody, Wyoming

This large version of Waiting for a Chinook *is the only known replication of the scene that brought Russell his initial recognition.*

tion until about 1903, when he produced a larger watercolor version painted for the Butte businessman T. P. Browne.

Russell biographers Ramon F. Adams and Homer Britzman have claimed that young Charlie purchased his first modeling clay and "an outfit of oils" in 1881, a year after he arrived in Montana. The date may or may not be exact, but the apparent motivation is of interest. Charlie had evidently just failed as a suitor of his first love, Lollie Edgar, the daughter of a Saint Louis family who had moved to the Judith Basin to ranch. She and Charlie, at least in his estimation, were meant for each other. But Lollie's father was not terribly impressed with Russell's future prospects, and she was sent back to Missouri to receive a proper college education. The courtship dissolved, and Russell was faced with a dilemma. He wanted to be in Montana and to run freely with Jake Hoover or push cows, but he also recognized a pull toward people of his own background. Perhaps in an effort to maintain a presence in both worlds, Russell saw his art as a bridge to respectability and social acceptance. Of special importance was his proficiency in oil painting. His watercolors and small wax figures served adequately as gifts to his fellow punchers or occasionally as swaps for drinks at the local bar, but he knew that serious exhibition pieces and commissions would demand oils.

Russell's first major oil, completed in 1885, is titled *Breaking Camp*. It belonged to his boss, Jesse Phelps, one of the owners of the OH Ranch, who had sent the small watercolor *Waiting for a Chinook* to Kaufman. So successful was *Breaking Camp*, in the artist's opinion, that he used it as a means of attracting attention back home in Saint Louis, as well as among his Montana cronies. It repre-

THE LAST SONG

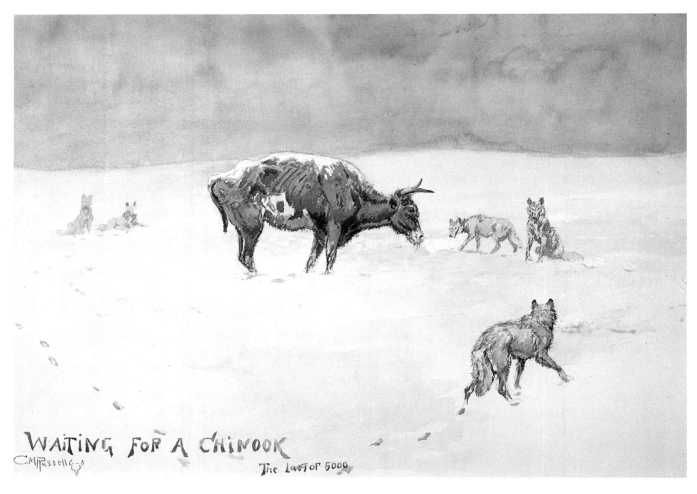

Waiting for a Chinook or *The Last of Five Thousand*

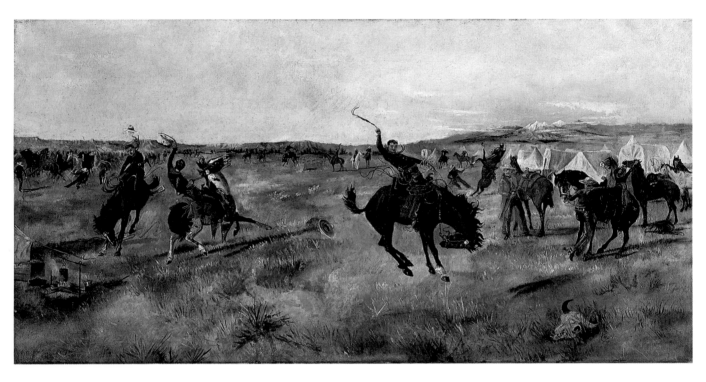

Breaking Camp

sented in a sense his reintroduction to Missouri and was accepted as part of the art collection of the third annual exhibition of the Saint Louis Exposition and Music Hall Association in 1886. Here was the roundup crew from Utica getting ready for a day's work, probably the same bunch he had been photographed with the previous year. There were twenty-five of them, and each one could find himself in the composition. To the Saint Louis audience, it was simply raw-bones western life. Spirited and exuberant, the first effort of a twenty-one-year-old painter proudly displayed a naive charm. With this work Russell formally extended himself beyond the cow camp and into the world of art.

Emboldened by this initial effort, Russell soon accepted a major commission from the proprietor of one of Utica's prime drinking establishments, James R. Shelton. The commission was convenient for both parties, since Charlie had been using a back room of Shelton's bar as his first studio. *Cowboy Camp during the Roundup* is an ambitious and complicated depiction of the old town and the cow camp, reminiscent of the 1884 group photograph of the roundup crew.

Although the landscape background and figural composition are less compelling than in *Breaking Camp*, the treatment of the sky and the brighter palette enhance this later painting. Typical of a naive artist's style, the work reveals Russell's inability at this point to synthesize rather than enumerate pictorial elements. Each individual of the roundup is portrayed separately; lacking even the focal point of the earlier work, it is read left to right like the page of a book. In the 1890s these two paintings were frequently illustrated together, giving the impression they were companion pieces. Even though they were not, their importance is clear, in that Russell, the fledgling painter, was working out pictorial conventions and searching for the best possible means of preserving the spirit of western life that meant so much to him.

One way of achieving even better results in his painting—results that would have gratified his patrons and his supporters back in Saint Louis—presented itself in 1887. That summer, while Russell was working on the large commission for Shelton, T. M. Markley purchased a group of watercolors. Markley recognized young Russell's artistic promise and offered to assist by sending him to Philadelphia for art training. They probably talked about the Pennsylvania Academy of the Fine Arts or perhaps Philadelphia's newly formed Art Students League. The *Helena Weekly Herald* was claiming that "within twelve months past the fame of the amateur devotee of the brush and pencil . . . has burst its bounds and spread abroad over the Territory." The newspaper article concluded that "all who know the young artist and see in his abilities the promise of a bright career for their possessor, hope he will accept Mr. Markley's proposition and go East to perfect the wonderful facilities with which he is endowed." Whether Markley was prepared to pay for Russell's schooling or not is unclear. It is clear, however, that Charlie did not avail himself of the offer.

About thirty-five years later Russell was quoted in a newspaper interview as saying that "art schools are good. Never went to one myself, tho. Never had money and had to work for a living." However, even if Markley had not been pre-

Breaking Camp

1885. Oil on canvas, 18½ x 36¼"
Amon Carter Museum
Fort Worth, Texas

Russell painted himself into many of his cowboy pictures and may be providing an early self-portrait with the figure in the tan slicker on the right.

Caught in the Act

1888. Oil on canvas, 20½ x 28¼"
Mackay Collection, Montana Historical Society
Helena, Montana

Somber and cold in tone, this early oil addresses the plight of the Indian peoples. Rather than provoking accusations or recriminations, it calls for understanding and the resolution of problems through communication.

Ranch Life in the North-West
(detail)

c. 1889. Pencil and watercolor,
dimensions unknown
Whereabouts unknown

The vigor of sketches such as this one captured the fancy of popular periodicals like Frank Leslie's Illustrated Newspaper. *As adapted for illustration with the aid of J.H. Smith, Russell's work initially reached a national audience.*

pared to pay the tuition in Philadelphia, it is difficult to believe that Russell's parents would not have underwritten such a venture. The real reasons for his decision probably reside in personal hubris and peer pressure. The boys did not want to see Charlie go, and besides, he had tried art school before in Saint Louis—some accounts say during his youth, and others suggest he went after leaving Jake Hoover in 1882—and he could abide neither the discipline nor the structure. Yet Russell's consuming sense of independence was the reason he used to explain his refusal to the eager press. The *Helena Daily Independent* in June, 1887, reported that Russell was headed back to the herd: [With] "what he will earn on the range this summer and fall, Russell expects to have enough money to defray the expenses of some art school in the east. He refuses to allow any one to pay his expenses, though he has received generous offers to that end."

Perhaps he did not earn enough. More likely, Russell felt that his artistic career was developing at a satisfactory pace. He had already earned the sobriquet "the Cowboy Artist" and was being touted as an original and vital artistic force in Montana. Moreover, cowboying was fun and surely would not last long, as the open range began to close in around him. So why not enjoy it awhile longer and face the question of art at some later date? Why take to heart what a Fort Benton newspaper would boast: "Let him have training and he will be to the west in art what Bret Harte was in literature—Independent"? He would ultimately achieve that stature anyway. In the spirit of the dime-novel heroes Russell still remembered, he strove to accomplish his goals as an artist without the intrusion of civilization masked in academic training.

The matter does not end in 1887, however, since Russell tossed the notion

THE LAST SONG

C. M. RUSSELL AND J. H. SMITH
Ranch Life in the North-West—
Bronco Ponies and Their Uses—
How They are Trained and Broken

May 18, 1889. Wood engraving

This joint illustration was a first for both artists in Frank Leslie's Illustrated Newspaper. *Throughout the next two years Smith produced a variety of western illustrations for* Leslie's, *which were the result of a trip he took through the North-west for the publication.*

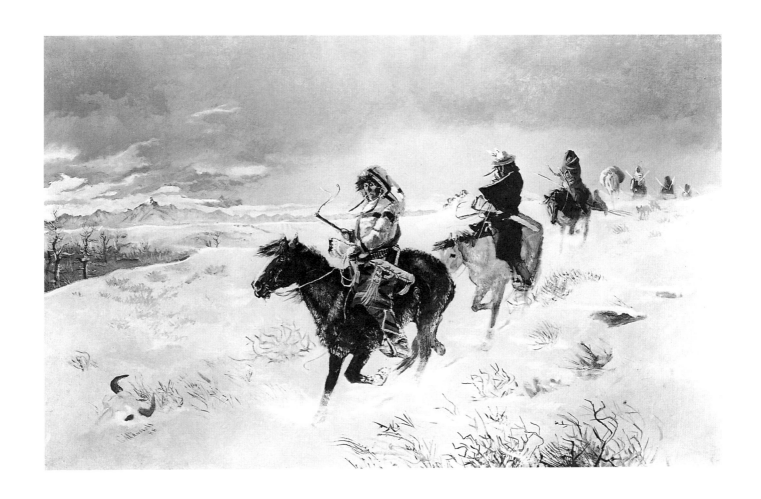

Going into Camp

1888. Oil on canvas, 30 x 48″
Private collection

Russell's reported winter stay with the Blood Indians could have produced images such as this. Much more likely sources exist, however, in Remington paintings of the period.

FREDERIC REMINGTON
Return of a Blackfoot War Party

1888. Engraving after the original

This painting—Remington's submission to the National Academy of Design in 1888—was illustrated in George William Sheldon's Recent Ideals of American Art *(New York: D. Appleton and Co., 1888–89). The image became readily available for eager fellow artists interested in depicting the West.*

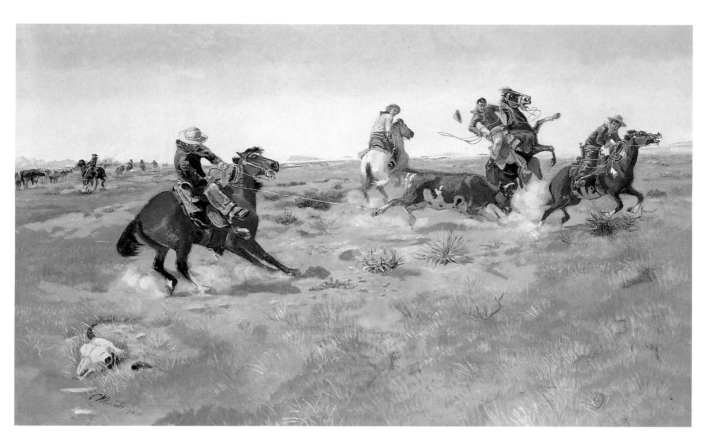

Scene Near Utica, Montana or *Judith Basin Roundup*

around again in subsequent years. In the fall of the following year, the *Helena Weekly Herald* announced that Russell was contemplating art study again, this time in Italy. But again he opted to expand his experience rather than his artistic talents. That winter, instead of visiting the academies of Rome and making the grand tour, he went off to live among the Blood Indians in Canada.

Russell probably calculated that, even if he could not paint better than anyone else who explored cowboy themes, at least he had better be able to claim more firsthand acquaintance with his subject than any other artists. There were few, even by 1888, who would contest the claim. But the Indians presented another challenge. He had much to learn, and he calculated that a lengthy stay among them would produce more immediate rewards than art school. Besides, the Indian's traditional ways of life were slipping away even faster than the cowboy's. As a final consideration, there was the matter of competition.

Russell needed to lay claim to his territory before someone else did. The situation was fairly urgent. In the summer of 1887 Frederic Remington had taken a special trip for *Harper's Weekly* to the Bow River and Fort Calgary in western Canada. That fall and the following winter Russell would see Remington's illustrations and stories of the Blackfeet and the Canadian police. The academic painter George de Forest Brush had published his artistic adventures among the Indians of Wyoming in *Century Magazine* in 1885. And the Cincinnati painter and illustrator Henry Farny, known for his sensitive treatment of Indian subjects, had just a year earlier produced a pictorial exposé on the Missouri River for *Century Magazine*. By 1887 Farny was also working for *Harper's Weekly* on western subjects. Russell, along with Brush and Farny, sympathized with the Indians, realizing that they, like his fellow cowboys and himself, were being forced out of existence. If there were to be a pictorial historian of these people of the far northern plains, Russell aspired to be that man.

There is considerable conjecture about the length of time Russell spent among the Bloods during the winter of 1887–88. Also in question is the validity of all his tales about whom he met, how he lived, and what Indian maidens were the subjects of his attentions. Yet there is little doubt about the impact made on Russell's mind by the experience. In a letter written to a friend named Charley in about 1891, he recounted that "I went out north across the line and lived six month with the Blackfeet[.] I had a pritty tough time." That he was among them long enough to experience a "tough time" was sufficient to create a genuine appreciation for their plight and their way of life. In the ensuing years of Russell's career, he painted more pictures of Indians than of any other subject. Equating their life with his, Russell generally elevated the Indians to an allegorical stature, portraying them as poetic defenders of nature against the malevolent forces of civilization.

Russell's claim to the Indians of the region and his expression of sympathy for them appear in his first published illustration, *Caught in the Act*. By its placement in the May 12, 1888, issue of *Harper's Weekly*, Russell balanced Remington's viewpoint, epitomized in his watercolor *Arrest of a Blackfeet Murderer* that had ap-

Scene Near Utica, Montana or *Judith Basin Roundup*

1889. Oil on canvas, 30 x 48"
Private collection

Of the myriad cowboy activities, Russell enjoyed roping most of all. He practiced it his entire life, in later years as a diversion and as exercise. In his art the rope was often used as a line of tension to connect contrasting forces of energy.

peared in the same magazine two months earlier. Remington portrayed the Indians as villains being brought to justice by the forces of good, the Royal Canadian Mounted Police. Russell depicted the Indians as victims, plagued by poverty and abuse, who out of desperation plundered the white man's cattle. Their starvation had been caused quite obviously by the demise of the buffalo and the concomitant rise of the cattle kingdom.

Despite the apparent incongruity of Russell's position as exposed here—his professional association with the cattle industry and his sympathy for the Indian's plight—he eagerly and concurrently exploited both themes. And he aggressively sought public exposure for the images he produced. Even quick impressions of daily ranch activity, such as pictured in *Ranch Life in the North-West*, were used to entice such international magazines as *Frank Leslie's Illustrated Newspaper* into publishing a full page of Russell vignettes celebrating the vigorous contests of man and horse on the frontier. No matter that, even as late as 1889 when the illustration appeared, it had to be reworked for publication by a second artist, J. H. Smith. Russell had opted for experience, credence, and vitality over technique. He presented the real thing. No Wild West show re-creations here, wrote *Leslie's*: "What the horses do on exhibition is as nothing to the diabolical contortions which they go through when endeavoring to unseat a cowboy rider on their native prairies."

Russell, having chosen not to pursue formal art training, became reliant on images he could find in published sources. These were especially helpful in guiding him toward compositional and figural placement. Remington's painting played an important role because he dealt with similar subjects and also because his imagery was readily available in published form. This is strikingly evident in a comparison of Russell's *Going into Camp* of 1888 with Remington's *Return of a Blackfoot War Party* of 1887. The composition of the two winter scenes is derived from French military painting of the day, with a column of soldiers (here warriors) proceeding forward across the picture plane at a diagonal from right to left. A bluff in the middle ground separates them from the distant horizon. The figures are prominent, rising in part above the horizon and dominating the natural element even in its harsh winter mantle. Yet there are also pervasive differences. Russell's warriors are pensive, withdrawn men plodding through the drifts and reflecting on the home fires ahead. Remington's men are contestants in a battle against one another as well as against nature. The viewer of Remington's painting is invited not to reflect on man in nature but to react emotionally to his savage inhumanity toward his fellow man. The winter harshness simply builds on the human brutality. Thus Russell derived his composition, but not his message, from Remington.

By 1889 Russell had settled into a pleasant routine. He could work the roundups in spring and fall and spend much of the summer and all winter painting and playing pranks with his friends. He had lived long enough among the cowboys to feel at one with their every move, and he enjoyed enough recognition among his admirers in Montana to enable him to explore artistic methods with-

The Wild West Indian Race

1885. Engraving, 4 x 8⅜"
Courtesy of the Buffalo Bill Historical Center
Cody, Wyoming

This souvenir program by an unknown artist is from "Buffalo Bill's Wild West" show, which traveled widely. The associated imagery quickly evolved into part of the popular perception about the West. These programs were printed in Hartford, Connecticut, in the mid-1880s.

THE LAST SONG

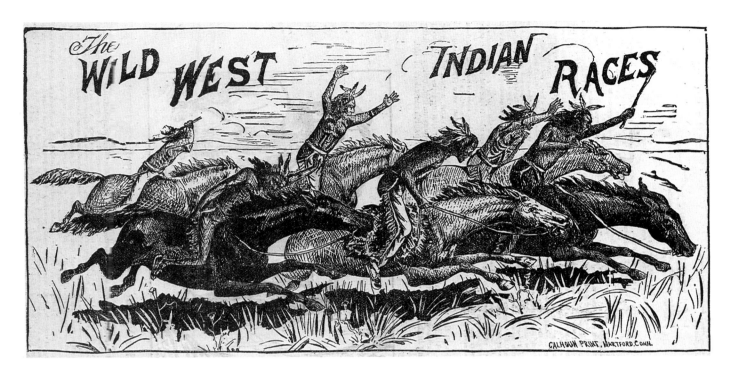

The Wild West Indian Race

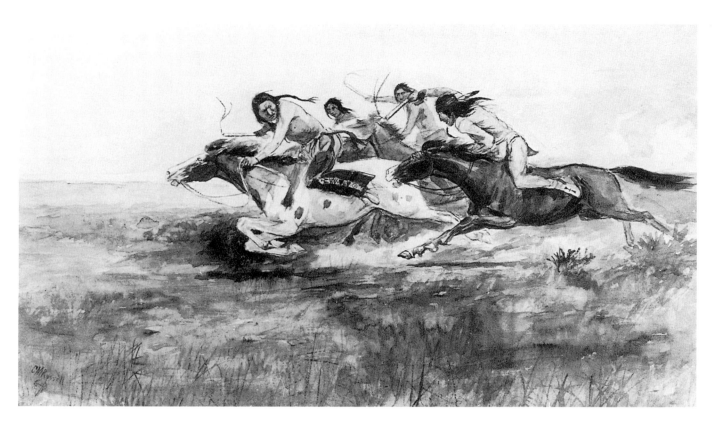

Indian Horse Race or *A Race on the Plains*

out fearing serious critical disapproval. Yet he did press himself to experiment, as with the variations apparent in *Scene Near Utica, Montana*. Instead of a diagonal line of figures, Russell now abstracted the linear direction of the predominant group. With the action still moving from right to left, he exploded the middle of the column and drew attention back toward the right of the composition, thus focusing on the renegade steer. Action, tension, and portent are here, all fundamental elements of Russell's mature style. Also presented, through the scale of the figures and their rise above the horizon, is man's dominance over nature. And, as Remington had done in his Blackfoot painting, Russell used a small genre element on the right side for compositional balance.

Despite Russell's residence in Montana, the dissemination of information through popular journals and the demands of public taste forced him to keep up with the times. As his skills as a draftsman and painter improved, his use of pictorial conventions also had to show progress. By 1890 photography had changed the way artists and the public looked at animals, particularly horses in motion. If Russell was to make a living by portraying the western horseman, he of necessity had to keep abreast of such developments. His painting *Cowboy Sport—Roping a Wolf* shows evidence that the lessons of Eadweard Muybridge's photographs and Frederic Remington's paintings had not been lost on the Montana artist.

Nor was Russell unaware of the commercial potential of such imagery. In 1890 he published his first book, *Studies of Western Life*, which was illustrated with reproductions of his paintings and, in its second edition, enhanced with a commentary by the Montana historian Granville Stuart. The book was printed in New York, and copyright was held by his friend Ben Roberts, a saddle maker then living in Cascade, Montana. The reproductions of Russell works proved so popular that the book went into a second printing before the year ended.

Russell was receiving so much favorable recognition that he began seriously to contemplate leaving the range and taking up art as a full-time vocation. The newspapers proclaimed him a native genius and by 1891 were condoning his decision not to obtain formal training. The August 18 issue of the Fort Benton *River Press* suggested, in fact, that lack of training may have strengthened rather than vitiated Russell's artistic gifts.

> He has never attended art school, but his work bears the mark of genius, he puts to blush the efforts of artists who have spent all their lives in studios. His figures stand out upon the canvas as living and moving, and every detail is faithfully and truly portrayed. In his particular line, Mr. Russell is a master, and we sincerely hope he will find it in his interest to give his entire time to his art work. He tells us he is fond of the work, and the only reason he does not follow it is because there is not enough money in it. We believe, however, that in his particular line he has no equal, and that his pictures, if properly handled, would bring him a fortune.

So what Russell now needed was not a stint in some European studio but a manager or dealer to help him reap the appropriate and deserved reward for his innate talent.

Indian Horse Race
or *A Race on the Plains*

1891. Watercolor, 13 x 23"
Private collection

In the early 1890s Russell was working toward a realistic depiction of horses in motion. He selected a popular theme from Indian life and the Wild West shows to explore these poses.

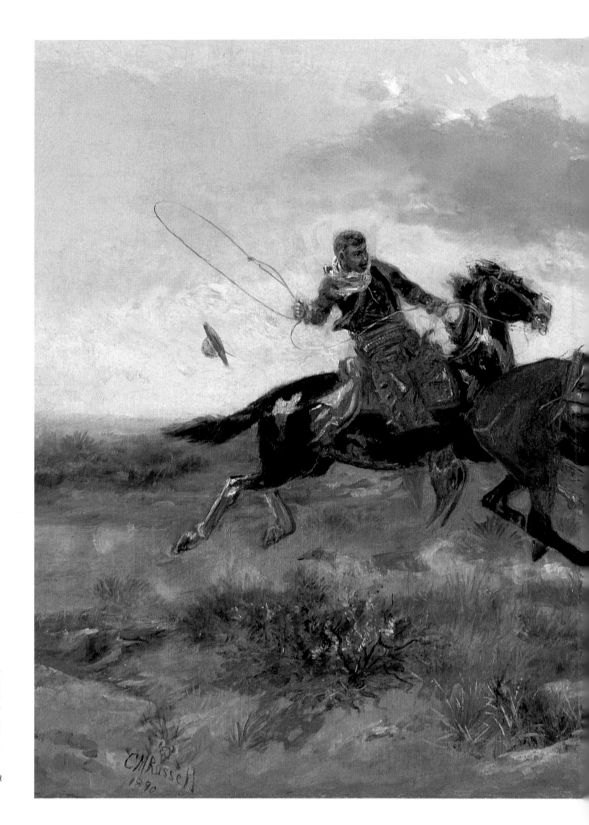

Cowboy Sport—Roping a Wolf

1890. Oil on canvas, 19¾ x 35⅝″
Courtesy Sid Richardson Collection
of Western Art
Fort Worth, Texas

*Like many painters of the day, Russell did
not come to realistic depictions of horses in
motion until after Eadweard Muybridge's
photographs became widely available from
published sources in the late 1880s.*

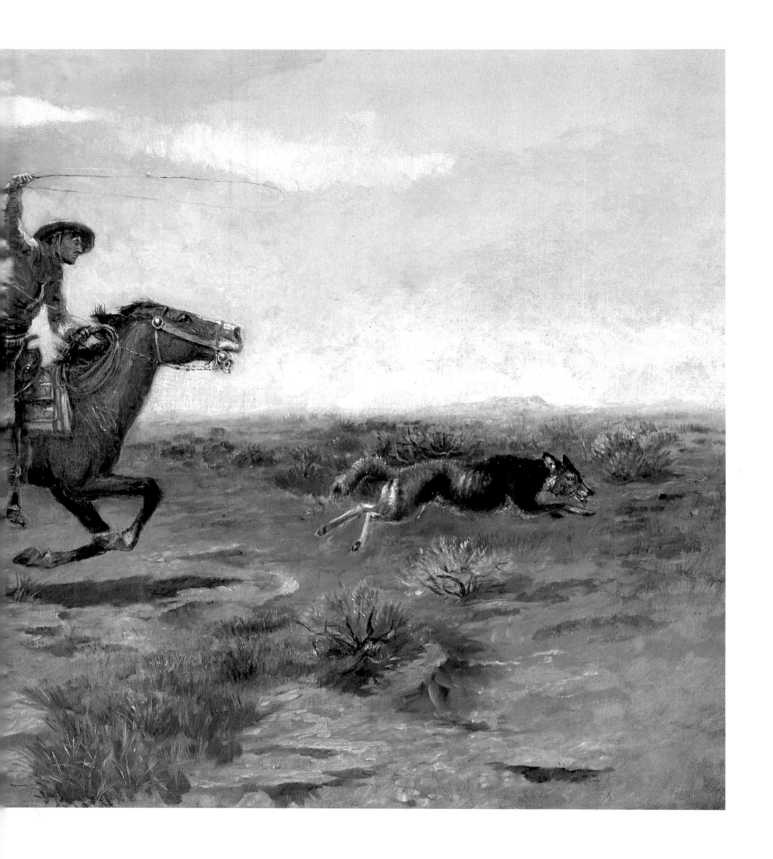

Russell is said to have drawn directly from natural observation. To a substantial degree, that is probably correct. However, popular sources upon which the developing painter could also rely were readily available. A Wild West show souvenir program might have provided the inspiration and theme for Russell's *Indian Horse Race*. In Buffalo Bill's arena such a dramatic sweep of horseflesh was cheered roundly by enthusiastic crowds. Russell knew that as part of his portfolio similar images would find acclaim; hence he produced a number of variations on the same theme.

By the early 1890s Russell's techniques began to show marked improvement. In his watercolor *Indian Horse Race*, the human figures are modeled and naturalistic. He also shows concern for the accurate depiction of a horse's legs in motion, revealing that he has been observing real animals if not Remington paintings and Muybridge photographs as well. Although the foreground landscape suffers from being unfinished, the dynamics of the picture are resolved through the focus on the central group.

In order to achieve more compelling and sophisticated compositions for his themes, Russell searched many available sources. The simplest finds were illustrations in such magazines as *Harper's* and *Leslie's*. J. H. Smith, for example, who had collaborated with Russell on the *Leslie's* illustration *Ranch Life in the North-West* in 1889, was being published widely by that magazine. In 1889 and 1890 readers enjoyed nine of his western illustrations, several of which inspired Russell compositions.

A more distant source of inspiration came from Saint Louis and Russell's mentor of a previous generation, Karl Wimar. Russell returned home on many occasions to visit family and refresh his supply of art materials. He also went home to learn some of the lessons Düsseldorf had to offer indirectly through Wimar's paintings. In 1890, at the annual exhibition of the Saint Louis Exposition and Music Hall Association, Wimar's 1853 canvas *The Discovery of Boone's Encampment in Kentucky by the Indians* was proudly displayed. The composition of that work and one of Smith's illustrations in *Leslie's*, *On the Western Plains—Friend or Foe?* which appeared in November of 1889, are strikingly close to that used by Russell in *Plunder on the Horizon*, one of his most accomplished paintings of the early 1890s. A large outcropping of rock provides a central pyramidal compositional device, also serving as a backdrop for the primary figures in the picture, a group of four Indians. The colors are rich and somber, serving to obscure the stealthy warriors and to heighten the drama of the scene. The right third of the picture is sunny and bright, with some prospectors in the distance peacefully panning for gold. The contrast of tonalities, the broken remnant of a tree cutting diagonally across the composition and penetrating the light side of the picture, and the visually unsettling rhythm established by the towering dark trees in the background set up symbolic tensions that are sophisticated, powerful, and effective. With a painting of such maturity, Russell was prepared to venture full-time into the world of art. After the roundup in the fall of 1893, he left the range and the life of the cowboy forever. He had spent eleven years in the business and was ready to move on to more creative challenges.

Plunder on the Horizon
or *Indians Discover Prospectors*

1893. Oil on canvas, 24 x 36"
Courtesy Sid Richardson Collection
of Western Art
Fort Worth, Texas

In some of Russell's paintings the symbols are thickly layered. Here the Indians are menacing; the somber colors enshroud them, and the broken log stabs the light. The innocently portrayed prospectors are depicted in clear light and appear free of malice or stealth.

THE LAST SONG

Plunder on the Horizon or *Indians Discover Prospectors*

Bronco Busting

III. Home off the Range

One of the best animal painters in the world is Charles M. Russell, of Montana, who is popularly known as the cowboy artist. His specialties are frontier scenes, wild Indian life, cattle pieces and natural history subjects, all of which are liberal in their similitude and imbued with a truthfulness of character and detail which is possible only for those to attain who are to the manner born.

Nature's Realm (1891)

"I F I HAD A WINTER HOME IN HELL and a summer home in Chicago I think Id spend my summers at my winter home," Russell wrote his neighbor Albert Trigg in 1916. He was recalling his first trip to that city back in 1893, the smoke and the crowds and the inexplicable loneliness that had consumed him. Perhaps he was also venting frustration over reaching the end of the line in his cowboy career in a curiously ironic fashion. Russell's last job in the cattle business was to ride the Great Northern Railroad with a load of beef for the Chicago stockyards. This was the same railroad that only a few years before had been completed across northern Montana, and whose presence signaled the demise of the open range and the cattle industry as Russell had known it. On the railroad came the agricultural settlers with their plows and barbed wire and civilization. So Russell rode out of the dying West into the choking cloud of progress, and with his long prod stick he coerced the cattle from the cars into the slaughterhouses. The whole experience must have distressed him as an unsuitable way to close one of the most fulfilling chapters in his life.

Yet he was also there to see the hope of tomorrow, the Great White City. Its very presence spoke of inevitable change, and he could not resist its augury. The World's Columbian Exposition pavilion of fine arts must have been especially inviting to Russell, whose life course was moving irreversibly in that direction. Among the many distinguished works of art were fifteen paintings and drawings by Frederic Remington. This may have been the first time Russell had seen any of his contemporary's works firsthand, and they no doubt made a lasting impression. One canvas in particular, *A Sample Steed*, reinforced Russell's conviction that the cowboy and bucking horse were as recognizable as fundamental American iconography as Deas's mountain man had been fifty years before. And if the

Bronco Busting

1895. Watercolor, 14⅛ x 20⅛"
Amon Carter Museum
Fort Worth, Texas

Bob Thoroughman was made legendary as a bronco rider by Russell. An old and loyal friend of Charlie's, he appears in many of the artist's paintings where horse and rider match strength and wits.

paintings in the gallery did not confirm it, Buffalo Bill's "Cowboy Fun" segments of his Wild West show would. Cody's tents and bleachers spilled over with spectators just outside the gates of the exposition.

Russell also identified directly with a relatively modest edifice among the masses of architectural grandiosity—the Montana pavilion, a "one-story structure, of Romanesque design." Here Russell was matched with his contemporaries, Cody and Remington. According to Herbert Bancroft's *The Book of the Fair*, "Russell, 'the cowboy artist' entirely self taught, has several subjects selected from incidents of his life, as 'The Bucking Broncho,' 'The Buffalo Hunt,' and 'The Indian Tepee.'" It must have been well worth the train ride for Russell to see his paintings in such revered company. And Montana had nothing to be prouder of than Charlie.

After touring the exposition, Russell went home to visit family in Saint Louis. They probably rejoiced in his decision to leave his drovers behind and may have played a role in connecting him with his most important early commission. The patron was William Niedringhaus, a Saint Louis entrepreneur who ran a hardware business in Missouri and ranches in Montana. In fact, Charlie had worked on Niedringhaus's spread, the N Bar N Ranch, and was pleased to be invited to provide the rancher with remembrances of life on the range.

A few years earlier, Russell had settled his belongings in Great Falls and es-

tablished a studio in "a business house" there. He had already begun to gather material he might use as props, and as early as November of 1892 the Fort Benton *River Press* published an article titled "Indian Relics," which applauded Russell's collecting habits and discussed the artist's use of such objects. But Russell found Great Falls a distraction now that he had a serious commission to fulfill. He had been used to single life with the boys each winter, painting when the need for extra cash or the spirit moved him, loafing and cavorting or playing pranks—many pranks, and almost always involving chickens somehow or other.

Without the time now for boyish diversions, Russell decided to move, and he chose the quiet little town of Cascade, about thirty miles southwest of Great Falls. The vacant courtroom of the local judge became his next studio. One of Russell's old friends, Vin Fortune, became his manager, helping with the packaging, shipping, and even pricing of works being sent to Saint Louis. Russell seems to have developed a network of friends who handled or assisted in the marketing of his paintings regionally. Albert Trigg promoted his work in Great Falls from the time they met in 1891; Kid Price sold his work in Chinook after 1892; and even a bartender in Great Falls, Charly Green, had offered to acquire all of Russell's output for a fixed monthly fee, but the artist refused the deal. There were a few galleries around the state, especially Calkins & Featherly in Helena and Charles Schatzlein of Butte, who showed Russell's work from time to time.

Of all these associates, it was Vin Fortune who surprised Russell with the amounts of money people might be willing to spend on his art—a pleasant and reassuring surprise, although Russell always remained aloof from such pecuniary matters. When the Niedringhaus commission was completed, it consisted of more than fifteen paintings for various family members. Most of them were watercolors, and most were of Indian subjects. But one cowboy picture, *Bronco Busting*, stands out as especially well considered. One of Charlie's old cowboy cronies, Bob Thoroughman, bounces confidently in the saddle as some other companions cheer him on. But there is confidence here beyond equestrian savvy, and that is artistic skill. Russell's draftsmanship, which underpins the delicate watercolor, is free and sure. The watercolor medium is handled deftly, and the artist has begun to work successfully on the modeling of form. The composition is a tried and true one for Russell—a central character on a pitching bronco, with a grouping of figures to the left and an uninterrupted, open landscape to the right or in the direction of the action, which allows the dynamics of the scene some anticipated space for resolution. The main figure extends above the horizon line, providing a statement of dominance over nature that is echoed in the horseman's ability to retain his seat on the wild bucker.

In the bucking-bronco painting by Remington, *A Sample Steed*, that Russell had viewed in Chicago, the artist placed the horse and rider in a composition devoid of natural surroundings. All attention is directed at the contest between man and beast. The cowboy as champion is idealized. Russell's motive was quite different. He sought rather to make the cowboy believable and human, to provide a visual means through which the viewer might associate with the rider rather than

Rider of the Rough String

1890. Oil on canvas, 14 x 24"
Private collection

Russell's action takes place in a real land-scape among real men. His drawing is still somewhat faulty at this date, but the genuine humanity of the scene is engaging and convincing.

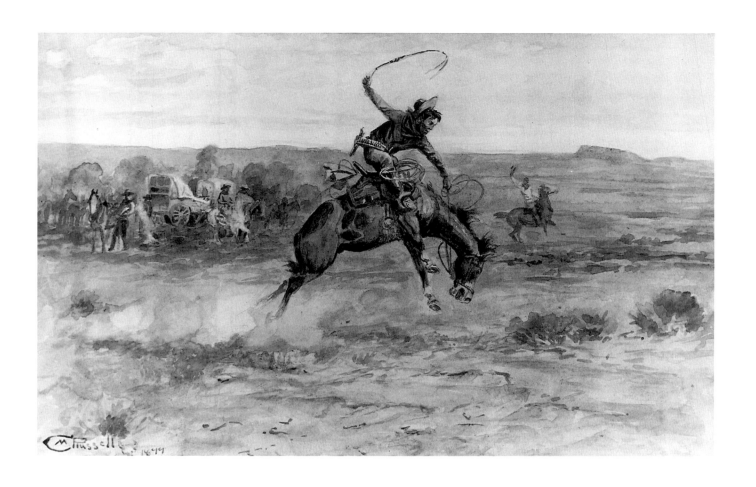

Bucking Bronco

1899. Watercolor, 14 x 22"
Museum of Western Art
Denver, Colorado

Because of Russell's consuming fascination for the most dramatic and vital elements of western life, he explored variations on several themes such as this one throughout his active career. As his drawing and technical skills improved, his figures became more fluid and his scenes more expressive of action.

revere him for sheer prowess. That is why the onlookers smile and cheer in Russell's scene. There is joy in Russell's view, whereas in Remington's there is machismo.

Throughout the decade of the 1890s Russell explored and expanded on the subject of the bronco rider. Once settled on a composition and theme that pleased his buyers and himself, Russell did not hesitate to repeat the success. Some critics would admonish an artist for such repetition, but for Russell it was both natural and without compromise. What counted was the ability to preserve the vitality and exuberance of such activities and continually upgrade the depiction of each one as his technique and skills matured. Thus one of his most accomplished early oils, *Rider of the Rough String* of 1890, is somewhat awkward and somber compared to *Bronco Busting*. And the relaxed fluidity of *Bucking Bronco*, a watercolor completed in 1899, surpasses that previous painting in handling, drawing, and modeling. Russell's variations on themes in no way hint at weakness of creative spirit, any more than the Madonna and Child theme did in the Renaissance. The variations were simply fundamental expressions of the developing western iconography of which Russell was becoming a prime exponent.

Of the recurrent themes in Russell's oeuvre, none was more thoroughly explored than the buffalo hunt. Except for a few early works in which Anglo hide hunters were portrayed in the methodical decimation of the herds, buffalo hunting for Russell was generally a grand enterprise reserved for the pre-reservation Indian. That Indian, symbolizing the Rousseauian natural man, was the single most significant symbol of the West for Russell. Such traditions as the buffalo hunt were far more profound than any of the ephemeral proficiencies of his fellow cowboys, and these traditions represented timeless and universal values that only the arts could preserve. Civilization had crushed the plains cultures. Despite the fact that the artist's vocation as a cowboy had indirectly caused the final depletion of the bison, Russell followed a self-enlightened mandate to celebrate and preserve the Indian image as noble. Just as he struggled to humanize the cowboy, he strove to idealize the Indian.

Romanticizing the Indian was nothing new for Russell, of course. His *Indians Hunting Buffalo* of 1894 pictures the elemental man: a proud, youthful plains bowman bare to the waist and ready to discharge a fatal arrow at his lumbering prey. His white horse leaps forward as if a charger beginning the joust, and the Indian himself, one with the thrust of the horse, suggests a Greek centaur in pose and force. The format of such a picture within the vocabulary of American art can be traced back to the 1830s and depictions of similar scenes by Peter Rindisbacher, Alfred Jacob Miller, and Titian Ramsay Peale. Russell represented a continuity of expression and a validation of long-sung interpretations of Indian life—noble, free, and at one with nature. The Indian whom Russell claimed as "the true American" would still wear the Arcadian shroud that George Catlin had placed on him sixty years earlier. Only now, with Russell, the statement was more urgently felt and the interpretation one of reflective hindsight rather than prophetic vision.

Buffalo Hunt No. 15

1896. Watercolor, 14⅜ x 21″
Amon Carter Museum
Fort Worth, Texas

The death pangs of the frontier found fertile expression in Russell's paintings of the late 1890s. Symbolic of the West's demise, the Indians in this painting fight a bitter battle with the mainstay of their own life and culture.

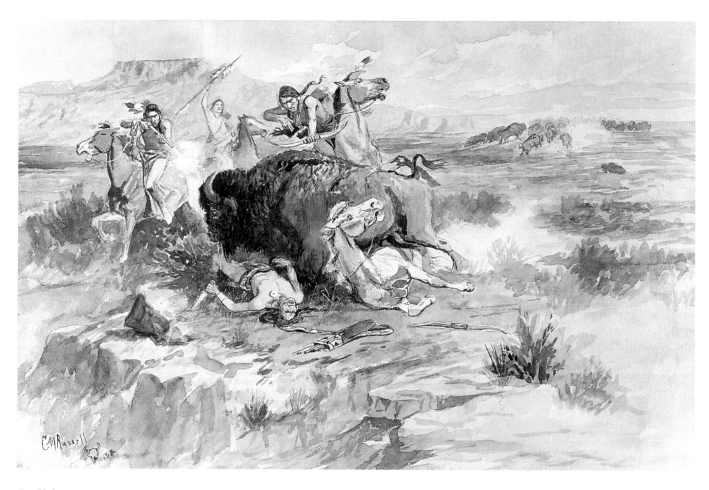

Buffalo Hunt Nɔ. 15

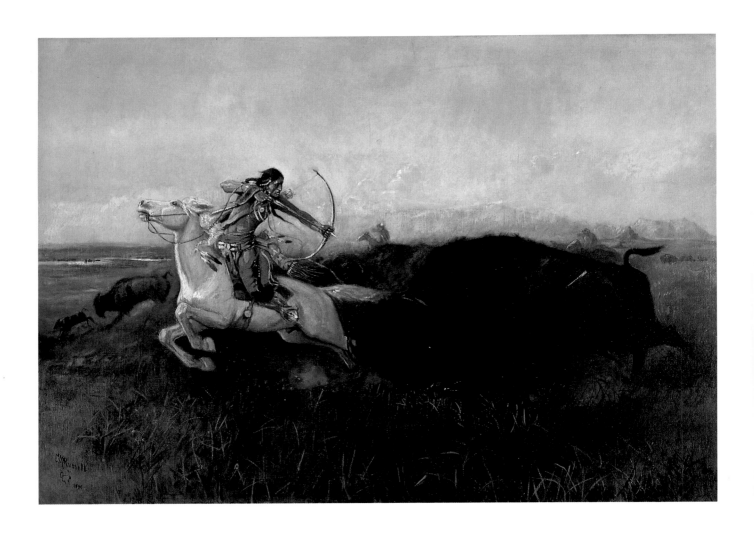

Indians Hunting Buffalo

1894. Oil on canvas, 24⅛ x 36⅛"
Courtesy Sid Richardson Collection
of Western Art
Fort Worth, Texas

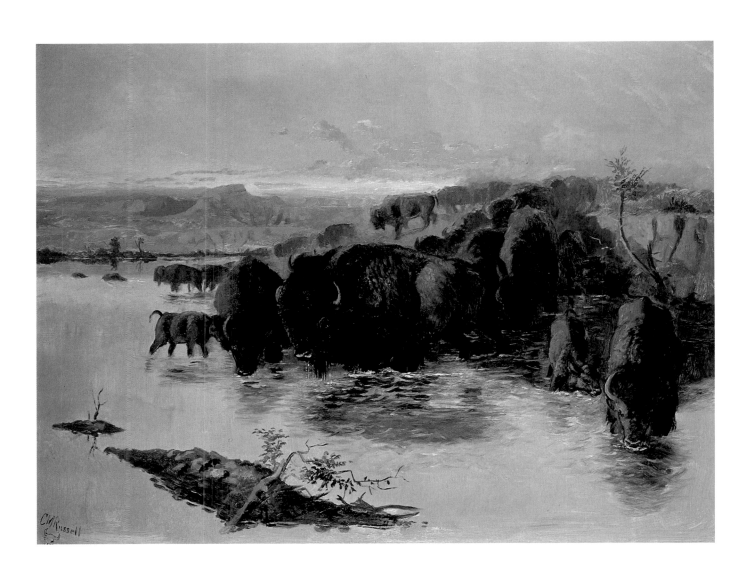

The Buffalo Herd

c. 1895. Oil on board, 17¾ x 23¾"
Courtesy of the Buffalo Bill Historical Center
Cody, Wyoming

The buffalo served as the symbol of the West, and the once ubiquitous herds expressed the region's riches. Russell enjoyed nothing more than re-creating those days when the wilderness teemed with these animals.

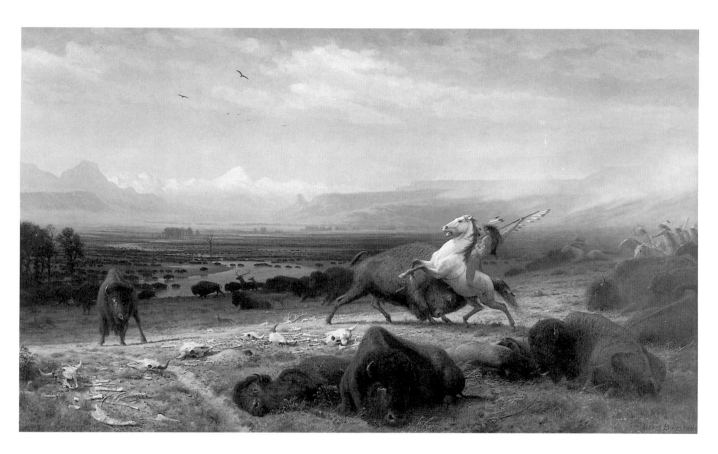

ALBERT BIERSTADT
Last of the Buffalo

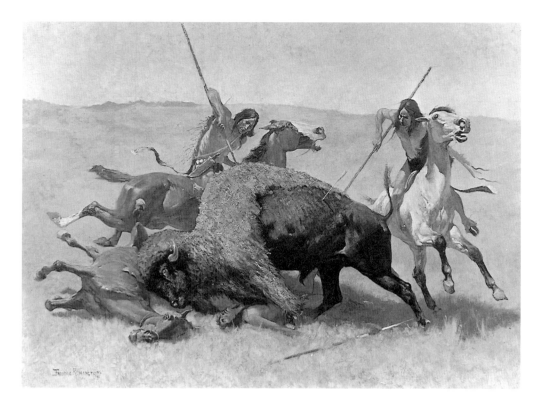

The construction of Russell's *Indians Hunting Buffalo* owes much to artistic conventions that came from a land he never saw—Germany. That frozen moment of action, that drama and portent, that final instant when destiny or life is determined were all part of the pedagogy from that most fertile of art schools, the Düsseldorf Academy. The American teacher there, Emanuel Leutze, termed it the "Düsseldorf tableau style," and he converted many students to its tenets. Wimar passed these lessons on to Russell, who perfected them in his own personal way. The somber russet tonalities, the focal white horse, and the stage-like setting for the central action were all part of the debt Russell owed to Wimar and Düsseldorf. Even the brands of paints Russell used most frequently were made in that German city.

For a number of years Russell expanded on the buffalo-hunt subject by incorporating an element of agitation, physical agony, and anguish. Such a scene appeared in one of the Niedringhaus commissions, *Buffalo Hunt No. 15*, painted in 1896, and there were similar adaptations in some of his cowboy roping pictures of the same period. The pervasiveness of this imagery is somewhat difficult to explain, as it seems uncharacteristic of Russell's nature. Perhaps the explanation lies in the popular demand from patrons who wanted more than just a picture of action. Remington had advanced such a violent and morose pictorial exclamation back in 1890 with his *Buffalo Hunt*. Although there is no proof, Russell most likely saw this painting and modeled a series of works after it later in the decade. The theme of death filled Remington's canvases throughout his career,

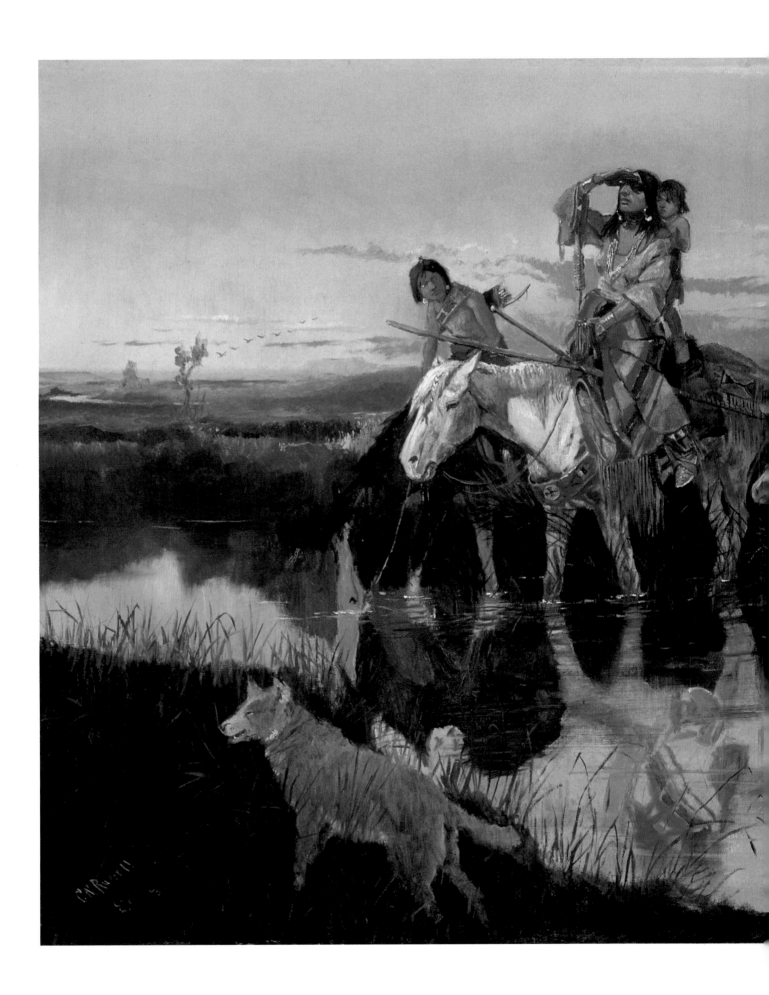

Bringing Up the Trail

1895. Oil on canvas, 22⅞ x 35"
Courtesy Sid Richardson Collection
of Western Art
Fort Worth, Texas

The Indian family depicted here epitomizes peace and grace. The group is metaphorically united with nature—literally reflected in its surface and quenched by its waters.

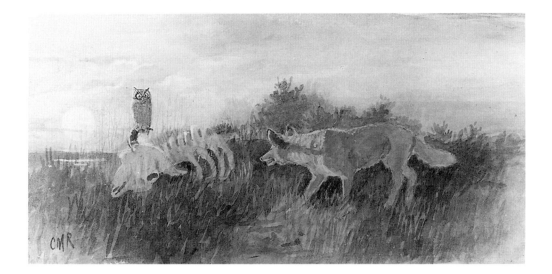

Night

c. 1895. Watercolor, 5 x 10″
Private collection

The owl symbolizes death for some Northern Plains Indian peoples. To have it perched on the horn of the buffalo skull was Russell's way of subtly expressing the notion that the frontier had vanished.

but for Russell there was only a brief period of five or six years when he favored such depictions.

Both artists were indebted to the American landscape master from Düsseldorf, Albert Bierstadt, for initially developing the symbolism of nature's demise through the buffalo-hunt image. In 1889 he had produced a huge salon piece, *Last of the Buffalo*, for exhibition at the Paris Exposition that year. It was the final expression of a theme Bierstadt had conceived in the early 1860s—a lament about the passing of the West, the demise of the buffalo, and the press of civilization. Yet in all its epic grandeur, *Last of the Buffalo* was a deceit. He had, in his own words, "endeavored to show the buffalo in all his aspects and depict the cruel slaughter of a noble animal now almost extinct." But the truth was not that the Indian had decimated the herds—and died in the process, as symbolized by the dead horse and Indian in the foreground—but rather that the hide hunters, cattle ranchers, and railroads had done the job. Bierstadt's dramatic allegory was deceptive and rueful. However, the message may have been a strong one for Russell. Perhaps it helped explain away some of the paradox of his own partial involvement in the diminution of the last great herds.

In any event, once the herds vanished, they, like the pre-reservation Indian, claimed a warm place in Russell's heart. In his day he garnered the reputation as the best painter of the buffalo. His quiet, reserved portrayals, such as *The Buffalo Herd*, proved his skill as an animal painter while revealing the reverence he felt for these monarchs of the prairie. With such sympathy for and pride in these beasts, it is little wonder that the artist chose the buffalo skull as part of his monogram. As the herd bull stops to drink from the river, he embodies the unity of natural elements, and when Russell signed the painting, he entwined his own psyche with the land and wildlife of Montana.

For the nineteenth-century artist, nature was charged with psychological associations. Values and meanings were directly connected to geological and climatological forces, as well as to animals. Thus the buffalo bull represented

dominance and nobility, and the river persistence and longevity. Russell built on these standard associations by adding Indian lore to the equation. When he painted his watercolor *Night* about 1895, he was heaping onto nature a heady burden of human moral analogues. The bison, once ruler of the plains, has fallen, and its bones sink into the sands of time as ashes or ruins of some crumbled past civilization. Perched on the bison's horn and representing death, the owl fixes its piercing gaze on the stealthy wolf arrived to search the wreckage for vestiges of plunder. As other nineteenth-century animal painters such as Peter Moran were wont to do, Russell invested the wolf and owl with human traits to act out human roles—all part of the romantic vision of the day.

Even more metaphorical was Russell's ink wash drawing *Old Days and New*. The composition, divided by a jagged diagonal, contrasts the ruins of a past innocent natural culture with the invasion of stifling order and a machine age. The burial scaffold teeters over the direct horizontal that transects the picture and provides a line on which the train will move unhindered from one limit to the other within the picture frame. The wolf or coyote regards the intrusion warily, wondering at its place in the new order of things—perhaps extinction like the buffalo beside it?

Such subjects took Russell back time and time again to expressions of man's harmony with nature. He often and sympathetically portrayed the movement of the tribes and daily life within the Indian camps, finding personal assurance as well as artistic challenges in these subjects. A favorite was the Indian women and children following in the wake of the hunters, as in *Bringing Up the Trail* of 1895. Russell had painted a similar version of this scene in 1892 titled *Following the Buffalo Run* (Amon Carter Museum, Fort Worth), in which mother and son lead a band toward the hunting ground. *Bringing Up the Trail* is a far more accomplished picture, with the reflecting water replacing a barren prairie in the foreground and the modeled tonalities of the sky in the distance. The only detraction in the later painting is the dog, which lacks finish and form.

Thoroughman's Home on the Range

Russell was also taken with the domestic scenes he witnessed among the ranches and Montana settlements. A cowboy's courtship, Christmastime at the line camp, and even his old pal Bob Thoroughman inspired Russell (*Thoroughman's Home on the Range*). These were simple genre pictures that related to events in the artist's personal life. In 1896 Russell had married Nancy Cooper, a sprightly young woman from Kentucky whom he had met in Cascade at Ben Roberts's home. He was thirty-two at the time and happy to settle down. She was eighteen and ready to help Charlie expand his horizons and find his fullest potential as an artist. She became a fundamental force in his life, guiding his career from that point onward. They worked as a team—he did the painting, she handled the marketing. It was an ideal situation, at least for Charlie. And Nancy seems to have thrived on the role of manager and businesswoman. She was probably even responsible for helping to create and maintain his public image, including his dress and lingo, so that his western eccentricities might make him marketable to an eastern audience. Charlie's nephew Austin Russell, who knew Nancy in later years, observed that she was driven by success and that her obsession naturally carried over to her husband. "Nancy got action out of everyone around her," he wrote. "Nobody could accuse her of driving Charlie, but without her he would have amounted to very little."

For Russell, old friendships and memories of past times meant more than security and wealth. The result was an enduring tension between the couple that, if nothing else, kept the relationship lively. He called her "Mame," and she knew him as "Chas." It was not long into their marriage before they knew each other's role. As Charlie once put it, "Mame's the business end an I jest paint. Were partners. She lives for tomorrow, an I live for yesterday."

Russell's art seems to have changed little as a result of marriage. Perhaps his output was enhanced without so many distractions from the boys. And during the early years with Nancy he did produce a number of sentimental animal pictures, for example, family groupings of deer that are a sanguine, if not somewhat saccharine, metaphor of conjugal bliss. One long-lasting change did take place, however. After about a year, they agreed that Cascade promised little in the way of art sales, so they moved to Great Falls, where they would remain for the greater part of their lives together.

About 1895 Russell had started to experiment with an interesting composition involving the massing of several mounted figures in a central inverted pyramidal format. It proved to be an extremely successful arrangement for his subjects, and he used it for action paintings as well as for those with static configurations. Sometimes a group of fighting Indians charge across the picture in profile, as in *Indians Attacking* (Amon Carter Museum), or some cowboys in three-quarter view gallop toward the viewer, as in *The Posse* (Amon Carter Museum). There were many potential variations, but the important point is that Russell had begun to produce complex figural work with stable, cohesive, and integrated compositions. The narrative could thus be consolidated into a uniform, concise statement, considerably more powerful and comprehensible than the frieze-like

Thoroughman's Home on the Range

1897. Watercolor, 9⅛ x 13″
Courtesy of Mrs. Carter Williams,
on loan to the C. M. Russell Museum
Great Falls, Montana

Domestic scenes like this one would seem to be an anomaly for Russell. However, during his courtship of Nancy in the mid-1890s and shortly after their marriage he displayed affection for such a settled life.

The Hold Up

1899. Oil on canvas, 30⅜ x 48¼"
Amon Carter Museum
Fort Worth, Texas

Given Russell's proclivity for literal transcriptions of narrative, the groups in this painting are united compositionally by a line of sight from Big Nose George to his hapless prey. The painting reads from left to right, as with words on a printed page.

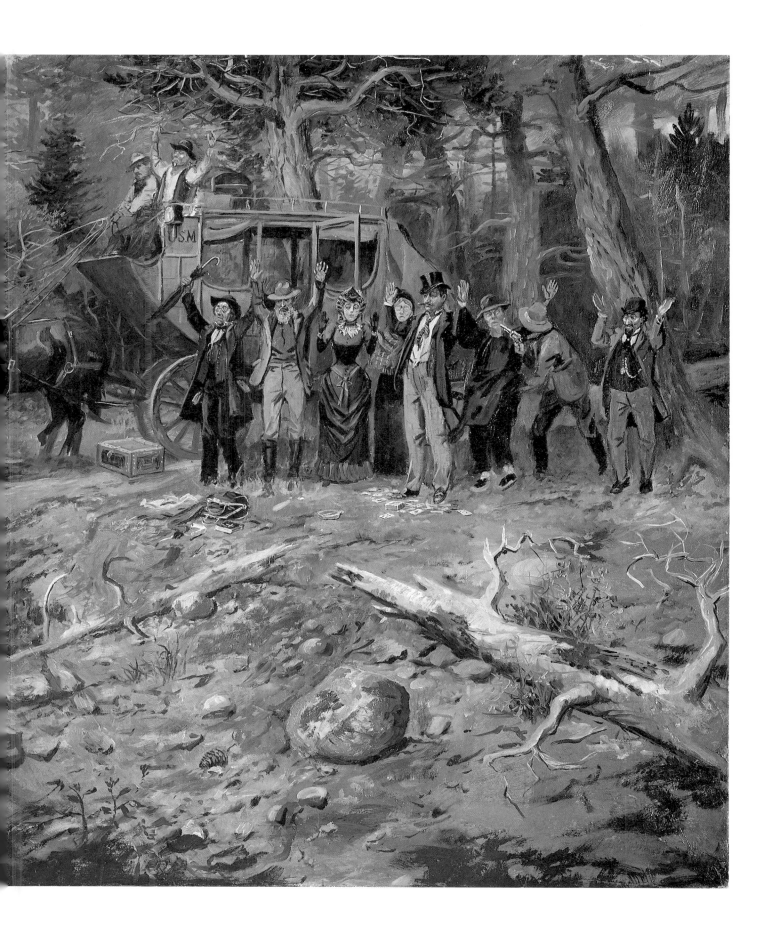

The Alarm

Holding Up the Stagecoach

1894. Watercolor, dimensions unknown
Whereabouts unknown

The holdup theme enjoyed wide popularity among illustrators as early as the 1860s, when artist Theodore Davis was aboard Butterfield's Overland Dispatch at the time it was attacked by Indians between Atchison and Denver. Russell never knew Big Nose George, but, thanks to the artist, the nefarious bandit was remembered by generations who perceived such escapades as romantic.

compositions of the late 1880s. Even when he chose to fill the horizon with riders fanning out in many directions, as in *The Alarm*, he targeted attention on a central group.

Yet when a complex notion confronted Russell, he retreated to former conventions. Such is the case with *The Hold Up*, one of his major paintings from the end of the decade. The backdrop of trees provides a cohesive element, with the diagonal road on the left and fallen tree on the right together leading the viewer's eye to the subject of the story, the strongbox. The rest of the picture is a lateral frieze of characters literally reading from left to right, starting with the signs tacked to the tree, which introduce both the subject of the narrative and its primary character, Big Nose George. The figures on the right, below the Deadwood Stage, represent the cast of characters who peopled the historic West—the preacher, the prospector, the schoolteacher, the widow who operated the boardinghouse in Miles City, the gambler, the Chinaman, and the New York dude recently arrived to open a men's store. To complement the area surrounded by trees, Russell selected rich dark colors punctuated with a bit of dappled sunlight and touches of crimson.

In palette and composition *The Hold Up* represents something of a step backward for Russell, yet it was immensely popular. It traveled to both the Saint Louis and Seattle expositions as part of the Montana state exhibits. The painting hung in one of Russell's favorite drinking spots, the Mint Bar in Great Falls, and even as late as 1914, the *Great Falls Tribune* reported that it was one of his most famous pictures, its popularity due to the fact that Russell had indulged in "a little humor along with a wealth of detail and splendid coloring effects." The artist was able to make light of Big Nose George's nefarious activities, to caricature the West

The Alarm

1898. Watercolor, 14½ x 21"
The Gerald Peters Gallery
Santa Fe, New Mexico

Despite the title of this work, Russell is probably portraying a fairly typical annual occurrence in cattle country. Here the "captain" of a cattle outfit sends his outriders in search of the scattered herds at the fall or "beef" roundup. On a good day and a big spread, the cowboys could bring in as many as ten thousand head by sundown.

through its various character types, and to produce a work of enduring appeal. Many considered the painting to be Russell's masterpiece of the century.

Russell's was a redemptive land, where even the outlaw enjoyed a revered place in the myth. His pictorial statement was comparable to the anachronistic vision of Howard Pyle and many of his Brandywine School protégés who searched Sherwood Forest for Pre-Raphaelite heroes of yore or South Sea islands for pirates living by a code of bravado and greed.

The Hold Up did not pop full blown into Russell's head, however. He had been working on a similar idea throughout the decade. One of the illustrations for his first collection of works, *Studies of Western Life* (1890), was a holdup scene. In the mid-nineties he had developed a series of paintings associated with the theme of highwaymen waiting for the stage. A watercolor of 1894, *Holding Up the Stagecoach* (present whereabouts unknown), and a pen and ink drawing of 1899, *Holding Up the Overland Stage*, might be considered preliminary works, and J. H. Smith's 1890 illustration for *Leslie's*, titled *Held Up*, may have inspired the notion that such a scene and composition held potential as a major painting. Russell's forte was in creating characters who could transcend their time and arrest the attention of a broad spectrum of American viewers. He fashioned the western myth in that way and set it firmly in the popular imagination.

Holding Up the Overland Stage

The Tenderfoot

IV. No "Wild West Faking"

I doubt not that those who may go through these rooms from time to time during the progress of the Exposition will surmise that some of the pictures are from the brush of Remington, or some artist of like renown. But not so, those who see animals in action, and some of the most captivating artistic work of the age on these pictures will find that an ordinary cowboy from the City of Great Falls, in our State, is shown to be the peer of Remington, and one of the artists destined to live in the history of art within the lines he has made his own.

Montana at the Louisiana Purchase Exposition (1904)

WITH THE OPENING OF THE TWENTIETH CENTURY, Russell stood proudly and confidently on the threshold of his dreams. He had lived one dream, the life of a cowboy, while that life was there to be lived, and he had now solidly embarked on a career as an illustrator and painter. He knew that his future lay in America's past, and he was ready to embellish the western myth and its reality, which were part of his fabric as a man.

In his several self-portraits of the period Russell shows, through his pose and demeanor, that he was in full possession of himself. He had established a presence that was eccentric yet of common cloth. His hand-rolled cigarettes, high-heeled riding boots, and Montana hat were everyday attire in Great Falls, though the "half-breed sash" and shock of blond hair down the side of his face were not, and none of it was customary outside of Montana. Yet Russell would not change because his costume was as much a part of his persona as his quick wit, laconic speech, and engaging appeal as a raconteur. There was nothing recondite about him, and he was proud of that. He considered himself lucky rather than skilled, and he was regarded by his peers as a modest and unassuming man. Some, such as his old cowboy buddy Con Price, regarded Russell as a man of complex nature, observing that "his pictures and work only tell a small part about him." Others, such as his protégé, artist Joe DeYong, remarked that "simplicity" was the word that best described him. But what emanates from Russell's self-portraits and the photographs taken of him is a personal pride, self-confidence, and sense of knowing that what he was doing would actually make a difference.

Russell wanted people to know, both his patrons and his friends, that he had been there, had taken part in the Old West, and was a measure better as a man

The Tenderfoot

1900. Oil on canvas, 14⅛ x 20⅛"
Courtesy Sid Richardson Collection
of Western Art
Fort Worth, Texas

Russell often used the dude to symbolize the advent of civilization on the frontier. He harbored no affection for these harbingers of doom masquerading as innocent dandies sent out from an effete society to do its bidding in the West.

69

Self-Portrait

1900. Watercolor, 12⅝ x 7⅛"
Courtesy of the Buffalo Bill Historical Center
Cody, Wyoming

There is speculation that Russell's special attire (sash, boots, and hat) was worn as much to capture attention as to provide comfort and portray tradition. Artists were supposed to be somewhat eccentric, and Russell did not shun this role.

A Quiet Day in Chinook

c. 1895. Watercolor, 19½ x 28½"
Courtesy of the California Department
of Parks and Recreation

The four-horse charge into town was traditional cowboy iconography by the time Russell used it in the 1890s. Chinamen, chickens, and mongrels scatter as the jolly horsemen of the plains come to town. Russell's ethnocentrism here may be blamed on the times and on the fact that he considered Orientals as harbingers of civilization.

because of it. Although he could not put himself in such scenes as *The Hold Up* (the event had occurred before his arrival in Montana), he frequently availed himself of such opportunities when credulity permitted. Hence, as a follow-up to his Big Nose George painting, Russell produced *The Tenderfoot*, a panorama of western types with whom he had rubbed shoulders. The composition, with the semicircular array of figures, is more controlled than usual. The prominent characters, however, are out of control: the proverbial antagonists in the match of frontier versus civilization—the bully and the dude. They connect, one to the other, by a violent diagonal spray of fire and lead that apparently amuses all those who have emptied the bar, except for the dog. In the shadows, behind the Chinaman, seated and obscure and least participatory of all, is the artist. Impartial in his countenance, Russell is passive witness to this "cowboy fun." And though it may seem one-sided here, the amusement ultimately represents an important gesture of the western cult to preserve itself from the high-buttoned, wool-capped personification of progress.

Dudes were not the only ones to find themselves in the way of the cowboy cult. The Chinaman scampered to the alleys or danced the .45-caliber high step in similar paintings and drawings. *A Quiet Day in Chinook* and *Making a Chinaman Dance* (Buffalo Bill Historical Center) are evidence of Russell's mild penchant for ethnocentrism. In Russell's mind the Chinaman deserved to be the butt of such humorous episodes. Although he might run the laundry now, the Chinaman had come west to help build the railroads, which put him in the same class as the dudes. Such interpretations, including the rush of four horsemen into town, were not new with Russell. Rufus Zogbaum, in an effort to alter the public perception of the cowboy from criminal hooligan to playful hero, presented a similar scene in *Painting the Town Red* (*Harper's Weekly*, October 16, 1886). Remington followed suit three years later with his *Cowboys Coming to Town for Christmas* (*Harper's Weekly*, December 21, 1889).

Russell would not play such games with the Indian, however, nor would he let the characters in his paintings or stories. "Man for man, an Injun's as good as a white man any day," he once wrote. "When he's a good friend he's the best friend in the world." The Indians deserved praise for their resistance to civilization, and Russell's *Indian Maid at Stockade* embodied such resolve. Her poise and stance, her décolletage, and her haughty expression are not manifestations of impudence but of pride. Had Russell been an Indian maid, he would have wished to look like this, and in many ways the picture compares with his own self-portrait. Charlie and Nancy often dressed in Indian garb from the studio, Charlie donning a black wig and makeup to help convince himself that such a transformation was not entirely impossible.

In 1900 Charlie received a small legacy from his mother, allowing the Russells to build a home. Nancy was gratified by the situation, which brought notice in Great Falls society and in the papers that had, up to that time, rather ignored them. By the summer of 1901 the *Great Falls Tribune* was describing Nancy as "a most estimable lady" and Charlie by nature a true artist. Maybe it took more than

NO "WILD WEST FAKING"

A Quiet Day in Chinook

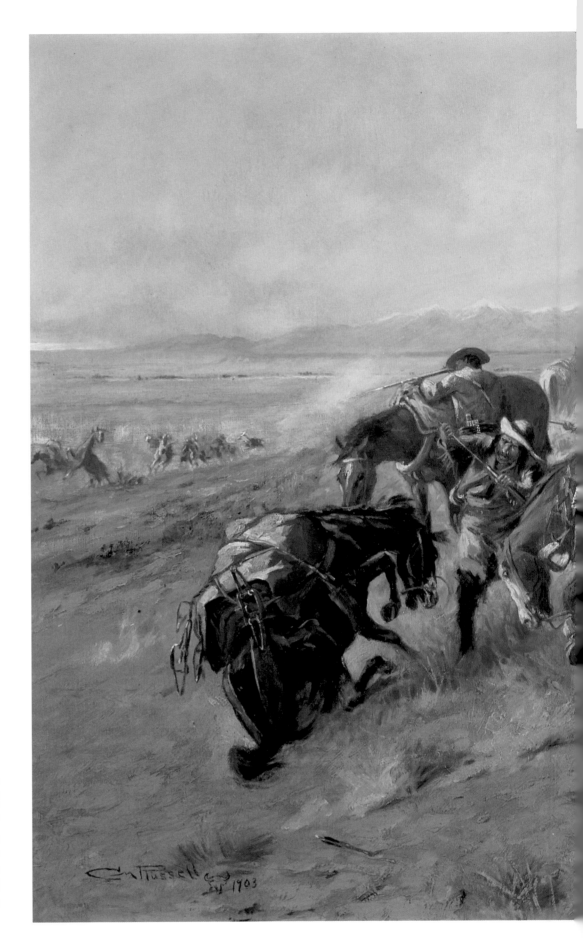

Caught in the Circle

1903. Oil on canvas, 24 x 36″
National Cowboy Hall of Fame and Western
Heritage Center
Oklahoma City, Oklahoma

The theme of the desperate stand was popular American provender after Custer lost his battle in 1876. Through the early years of the twentieth century, Russell explored the theme repeatedly and with considerable success.

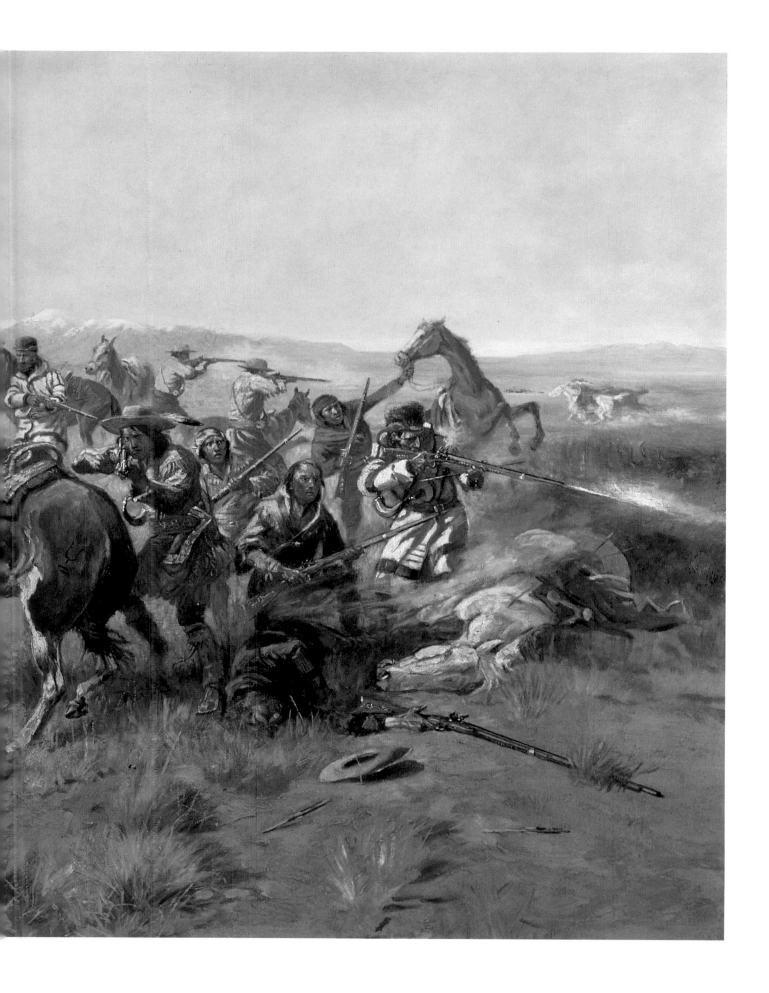

a new house to arouse excitement about the Russells. Maybe it was because Charlie was winning considerable acclaim outside of Montana that he and his wife began to be regarded as celebrities at home.

In the spring of 1901 Charlie and Nancy had visited his relatives in Saint Louis. They took a group of his paintings along, and Charlie was offered his first one-man show there, at the Strauss Gallery. Saint Louis was impressed. The newspapers all praised his work and were intrigued by the man and his story as well. Even before the Russells had returned to Montana, western papers had picked up the news. Headlines in the *Helena Independent* read: "Cowboy Artist, St. Louis Lion." Thus began a renewed attraction between Russell and his home-town, which rejuvenated and sparked his artistic vitality, as the Niedringhaus commissions had done nearly a decade earlier. The Russells were disappointed that the Saint Louis Museum of Fine Arts would not deign to acquire one of his paintings for its collection, which seemed somewhat ironic since the museum had recently broken ground for a new building that would serve as the art pavilion for the first westward-looking World's Fair, the Louisiana Purchase Exposition of 1904. It was also frustrating because another Montana Indian painter, Joseph Henry Sharp, had twenty-five paintings on exhibit in the museum's galleries at that time. Nonetheless, the publicity opened many eastern and western eyes to Russell's unique talents. The *St. Louis Post-Dispatch* claimed that "the man who may rival Remington and some day surpass the world's best animal painters possesses an individuality born of a close communion with the breath of life as realized in the far reaches of the west." Russell was thirty-seven years old, and he was pulling himself up over the ledge at the top. He could imagine no better company, and the view was splendid.

Probably the most sophisticated and complicated composition and the most compelling theme that Russell borrowed from Remington was the encircled guard. Typically, these paintings showed a group of frontiersmen surrounded by Indians and shooting from behind their horses. Remington had first successfully employed the subject and format in two paintings of 1888. His *Last Lull in the Fight* garnered a silver medal at the Paris Universal Exposition of 1889, and *An Episode in the Opening Up of a Cattle Country* appeared in the February, 1888, issue of *Century Magazine*. Russell had explored the idea in *Close Quarters* (Amon Carter Museum), a painting published in his first book, *Studies of Western Life*, in 1890. Through the years both artists produced numerous variations on this classic and mythic western encounter.

Remington had adopted the formal construction of these pictures from the military paintings of such French masters as Jean Meissonier and Jean-Baptiste-Edouard Detaille. He also tapped popular American vernacular sources, especially depictions of Custer's last stand. Russell also knew such images, which had been widely distributed as prints.

In the late 1890s and early 1900s, Russell executed a number of mature works based on this format, including *A Desperate Stand* and *The Trapper's Last Stand* (1899, R. W. Norton Art Gallery), the latter measuring six feet in width.

Indian Maid at Stockade

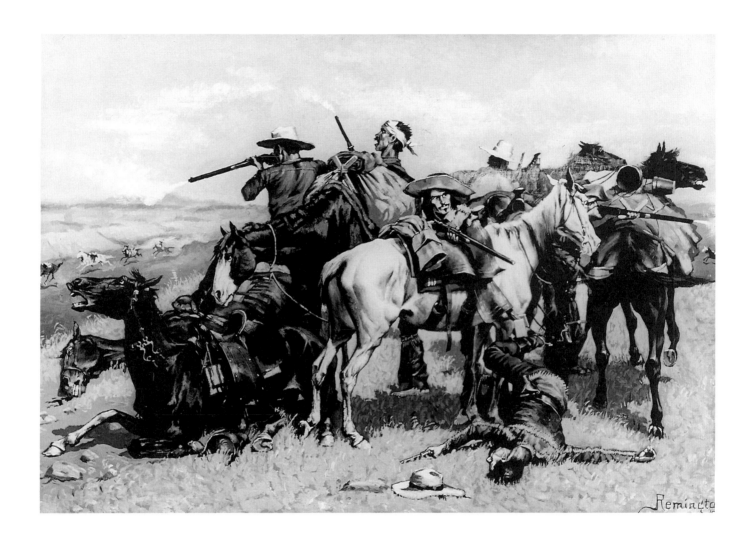

FREDERIC REMINGTON
*An Episode in the Opening Up of
a Cattle Country*

1887. Oil on canvas, 17¼ x 24⅞″
Gene Autry Western Heritage Museum
Los Angeles, California

*Remington's mode of expression involved
a test of man against man in the bitter
contest of empire. His resolute frontiers-
men—"Men with the Bark on," as he
called them—stand off the elements; in
this case, it is a group of encircling Indi-
ans. For a time Russell was enamored of
such subjects, although they represented
a philosophical bias that ultimately ran
counter to his own.*

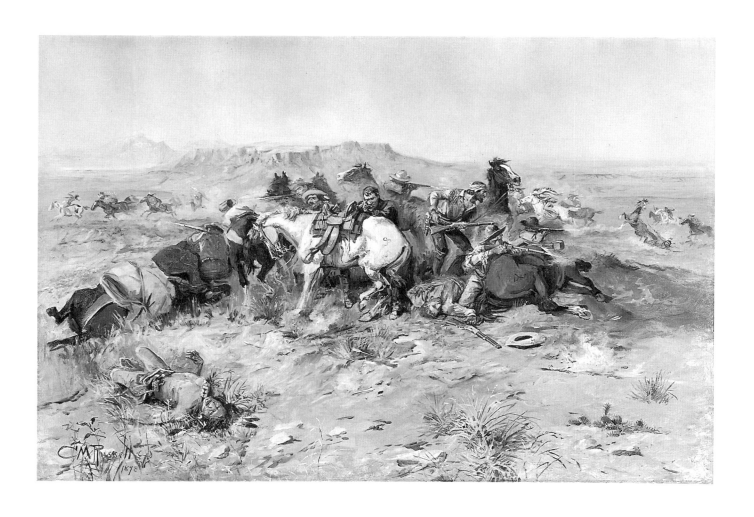

A Desperate Stand

1898. Oil on canvas, 24⅛ x 36⅛"
Amon Carter Museum
Fort Worth, Texas

This is Russell's interpretation of Remington's statement of epic men pitted against nature. Russell explored this subject for a while at the turn of the century but eventually abandoned it for themes expressing harmony, subtle paradox, and natural eloquence.

Perhaps his most accomplished version appeared in 1903, *Caught in the Circle*. Here the central figures dominate the composition in scale. Their finish is excellent, the poses are well developed, and the centricity of the composition is fully resolved. Russell even left less empty foreground than usual, thereby enhancing the immediacy of the action.

Over the next few years Russell's name and pictures were spread across the pages of newspapers throughout the West. A reporter from the *Chicago Record-Herald* visited Great Falls in the summer of 1902 expressly to interview the artist and see his studio, which was at that time simply one room in the house. The surroundings were described as "a veritable museum of cowboy and Indian curios." What most impressed the Chicagoan, beyond the openhearted welcome, the personal charisma of his Montana host, and the curious ambience of the Russell home, was a thin volume of drawings published in 1899 titled *Pen Sketches*. As he thumbed through the pages—from the first illustration, *The Indian of the Plains as He Was*, to the final one, *The Last of His Race*—the reporter recognized a very special capacity. Although Russell could perhaps not produce "a truer pen sketch than Remington," he possessed a remarkable human insight into the progression of events in western history, and he had articulated the irony, pathos, and foibles that hide beneath the surface of common occurrences. Here was an "unmolded orphan of the West, whose simple, honest nature conventionality could never spoil." Here was something as close to untempered native genius as the reporter had ever seen, and his resulting article, "The Cowboy Artist," aroused a considerable popular stir.

The *Denver Times* reprinted the Chicago story, as many other papers probably did. But where the impact was most strongly felt and appreciated was at home in Montana. Some snatches of biography, primarily focused on his cowboy days and his rise to local fame with *Waiting for a Chinook*, had appeared before, but in early 1903 the *Butte Inter Mountain* provided a full-page, narrated account with eight photo portraits of Russell and his horse. The artist was telling his own story and formally establishing his public persona. It started off with an error, the date of his birth, but the rest probably represented Russell's past fairly accurately. The piece mainly spoke of his cowboy years, with virtually nothing about his art or its motivation. But then Russell never was much good at expressing himself on his, or anyone else's, art. What came naturally and presented itself so plainly needed no verbal explication in his mind. Although by now he was being compared with Charles Schreyvogel as well as with Remington, and his paintings were in "their freedom and strength" deserving "a place in the best company," he still did not fathom the breadth of his potential fame or influence.

On the evening of October 8, 1903, an illustrator from New York arrived in Great Falls. John Marchand was looking for a chance to visit Russell, whose work he greatly admired. The *Great Falls Daily Tribune* obtained an interview and an explanation of why an artist from New York would come so far to glimpse a local phenomenon. "I have just been in a 'cow country' and have been attempting to do what he does. I don't think there is any one who can 'touch' him on his sub-

jects." Marchand was admitting that there were some important lessons to learn from Montana's homegrown talent that his own Munich Academy training could not provide. They were natural and experiential lessons rather than technical ones, but they were vital nonetheless.

Marchand did not find Russell home because he and Nancy had left the same day for Saint Louis. They hoped to have some paintings (two watercolors and two oils) and—something new—a few sculptures accepted by the selection committee of the World's Fair. They planned to spend several months in pursuit of this goal, and in the end the trip more than paid off. The Noonan-Kocian Galleries there hosted a one-man show for Russell. And, as they had hoped, several pieces found their way into the World's Fair, the 1904 Louisiana Purchase Exposition. Three paintings hung in the Montana pavilion and a fourth in the Palace of Fine Arts exhibition, so Russell's dream to show in the museum was at least briefly fulfilled. The painting, titled *Pirates of the Plains*, portrayed a group of Indian warriors coming across the prairies.

By early December the Russells were still in Charlie's hometown. He had expanded not only his audience but also the breadth of his expression. Both as a man of letters and as a sculptor, Russell was communicating on a new level. His illustrated letters to friends at home, such as Bill Rance at the Silver Dollar, were not only posted near the bar for all to see but published in the newspaper as well. The papers also announced that he was busy "modeling a number of figures and groups of western life and wild animals, which are being reproduced on a large scale to be erected in the World's fair grounds." Russell, who had toyed with sculpture most of his life—impressing his friends with his exceptional facility at modeling small forms in wax or clay—would find his first serious public display among the huge plaster monuments at the fair. He had not yet even cast his first statuette in bronze.

On a roll, the Russells decided to accept Marchand's invitation to visit New York City. They left for "the big camp," as Charlie called it, with a few paintings under their arms, some hope in their hearts, and a good deal of trepidation. Although New York was truly foreign to the Russells, they were welcomed warmly by a group of admiring local illustrators. Marchand shared his studio with Russell and made the rounds with his country cousin to many magazines, which openly invited the idea of fresh material from the West. Russell fit right in and, as he recounted on his return to Great Falls, "I met a lot of artists and illustrators. They are a mighty fine lot of fellows and they treated me out of sight."

As solicitous as New York was to Russell, his taste for home was strong. "I'd rather live in a place where I know somebody and where everybody is Somebody. Here everybody is somebody, but down there you've got to be a millionaire to be anybody." This philosophy would serve Russell for another decade or so, until he joined the Hollywood crowd out on the other coast.

Beyond confirming his attachment to Montana land and people, the New York experience had fundamental effects on Russell and his art. Two things changed as a result of his adventures with Marchand—the quality of his work

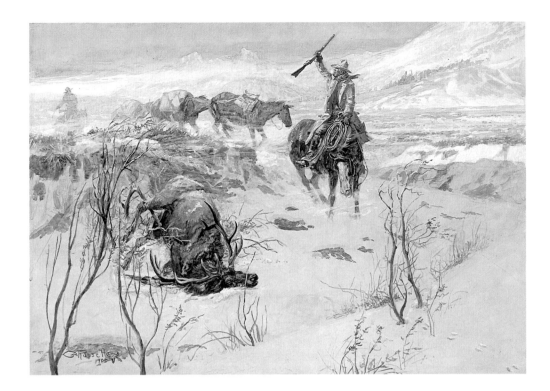

Christmas Dinner for the Men on the Trail or *The Prize Shot*

1905. Watercolor, 16 x 22¾"
Amon Carter Museum
Fort Worth, Texas

As this work indicates, Russell's painting technique in watercolor, as well as in oils, improved noticeably after his first trips to New York in 1903 and 1904.

and the direction of his criticism. There occurred in all of this a transformation from a cowboy who dreamed of being an artist to an artist who once was a cowboy. Almost overnight, those who reviewed his art began to analyze his paintings as paintings rather than merely as transcriptions of frontier life. The importance of picture-making rather than storytelling was paramount for his new critics. No longer could his laurels rest on having been a night wrangler for eleven years; he had to consider his art as it might now be evaluated on artistic merit alone. So, on the one hand, when the writer Kathryne Wilson recounted the standard biographical pitch in the 1904 *Pacific Monthly* article, "An Artist of the Plains," Russell felt comfortable. But in the middle of the piece, when she pointed to a fundamental fault in his paintings, Russell was forced to reconsider the style and techniques that had for so long held true for his Montana, Colorado, and Missouri audiences.

Wilson claimed, among other things, that Russell's paintings were impressive for their ability to impart action. She complained, however, that these works appeared to be unfinished because he neglected certain portions of the picture that he felt were unnecessary to convey the action. Foregrounds were particularly susceptible to this omission. In addition, his oils were weak and washy because of technical naiveté. Wilson used a stronger word—"ignorance."

> *Much of his oil work betrays . . . the influence of his practice in water color through the broad sweeps of suggestive tints, almost impressionistic in their effects—a device that is all very well in its place, but which is not always used discriminately by Russell. . . . There are many tricks of technique of the studio that Russell has not discovered for*

NO "WILD WEST FAKING"

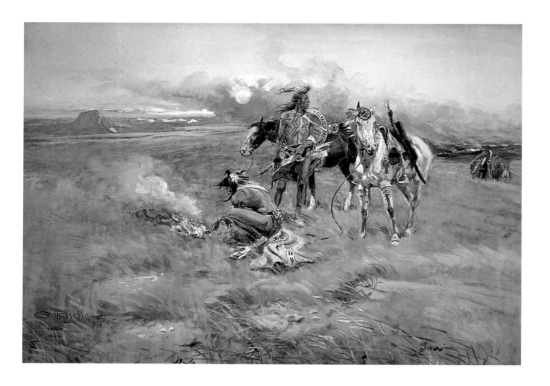

Blackfeet Burning Crow Buffalo Range

1905. Watercolor, 24½ x 31″
Courtesy of the Buffalo Bill Historical Center
Cody, Wyoming
On loan from the Estate of William E. Weiss, Jr.

Drama is literally carried on the wind in this painting. One of the warriors uses the wind as a tool to implement his task, while the other stands firm against it as if to assert his stature in the presence of nature's force.

himself and whose value he himself appreciates. "What I would like most," he says, "is to know how artists lay on color. I would like to have a chance to study in some good studio."

In his determination to remain uninfluenced by art schools because it looked better on his résumé to be an "unspoiled genius," Russell now found himself technically limited. Fortunately the problems were surmountable because he was a fast learner and a student adaptable to the world around him. The years directly after his first trip to New York were broadening, efficacious, and productive.

Russell had already begun to lighten his palette as early as 1897 and 1898. These changes, according to his devoted biographer and scholar, the late Frederic G. Renner, came about as a result of contact with eastern publishers. Especially important was advice he received from art editors of such magazines as *Recreation* and *Field and Stream*. This is particularly evident in his watercolors, where a new vitality envelops the tinted washes. Further important advances are seen in his watercolors of 1905, after a second visit to New York and additional exposure to Marchand's studio, other art editors, and fellow painters. Russell signed a contract with the calendar company Brown and Bigelow, which may also have invited advice and a critique of his work. Although the source of inspiration remains uncertain, the impact was noticeable. In Russell's watercolors these changes are readily seen in his facile application of opaque or Chinese white. Particularly effective in creating winter scenes such as *Buffalo and Wolves* (1903, Rockwell Museum) and *The Prize Shot*, the opaque pigments give the scenes an effect of atmosphere and temperature of light never before accom-

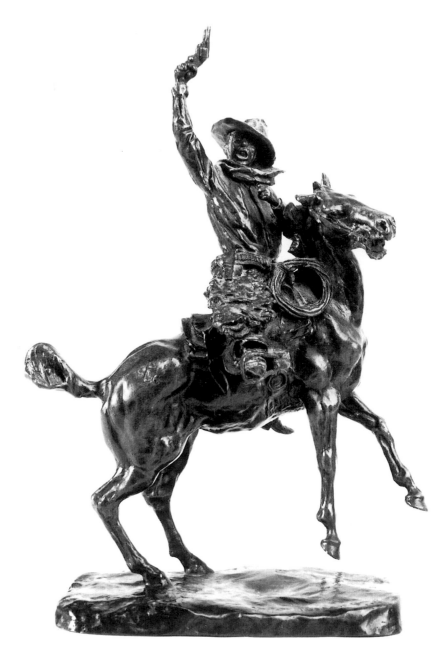

Smoking Up

1904. Bronze, height 12⅛″
Collection of Fred and Ginger Renner

Russell's first statuette to be cast in bronze was an immediate success. Produced by the Roman Bronze Works of New York, this figure of a rollicking cowboy adorned the windows of Tiffany's in New York and opened the world of serious sculpture to Russell.

Buffalo Hunt

c. 1905 Bronze, height 10″
Amon Carter Museum
Fort Worth, Texas

plished by the painter. The beguiling freshness, natural charm, and lyrical hue of these works led Marian White of the *Fine Arts Journal* to observe perceptively that Russell was "no longer a painter of stern realism, but rather a delineator of the poetical." Russell had mastered the evocation of mood.

Added to these technical innovations was Russell's increasing sophistication as a draftsman. By 1905 his handling of human and equine form had reached its peak. Together with newly honed skill in depicting atmosphere, his elevated drawing ability produced exalted work such as *Blackfeet Burning Crow Buffalo Range*.

Russell's improved drawing skills may have had a direct relationship to his serious involvement with another medium at this time. On his first trip to New York he took up sculpting statuettes and subsequently, at the urging of Nancy, had the first one, *Smoking Up*, cast in bronze in 1904. Russell had always been re-

NO "WILD WEST FAKING"

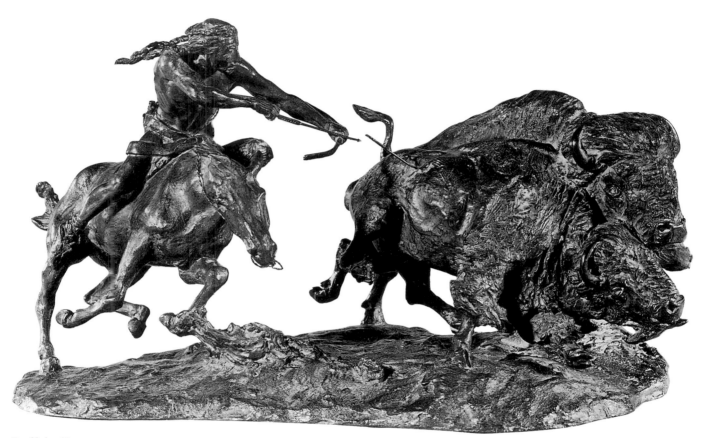

Buffalo Hunt

The Beauty Parlor

laxed with modeling, having actually claimed a preference for wax over paint as a means of aesthetic expression. He also used clay and wax models as studies for painting to work out shadow effects, compositional association of figures, and poses. Plastic form came naturally to him, and as his work progressed in three-dimensional pieces, his drawing skills also sharpened.

Previously Russell had not taken his sculptural work seriously. What he had created earlier were generally small figures crafted from a lump of wax he carried in his pocket. Once completed, these were either given to friends or mashed into a ball for him to reuse. He would often model in this way as he told stories, and onlookers were intrigued with his deftness. According to the *Butte Evening News* in 1905, hundreds of people owned Russell's wax figurines by the time he cast his first bronze.

The bronzes were an immediate success both east and west. In New York City, Tiffany's carried them, along with Remington bronzes. The *Buffalo Hunt* and *Counting Coup* commanded prices of four hundred fifty dollars each, roughly the same as Remington's bronzes of the period. Russell's were freer and more spirited in execution compared to the rather monumental academic presentations of his New York contemporary. Remington never deigned to comment on Russell's sculpture, but Solon Borglum did, once remarking, "Would that I could get such wonderful and magnificent spirit that makes Russell's modelings so alive."

In 1907, after visiting New York on a number of occasions, Russell was offered his first one-man show there. The invitation came from Newell Dwight Hillis, a Brooklyn preacher, and the works were borrowed not from Russell but from two of his Montana patrons. After a venue in Hillis's church, the exhibition was slated for the Waldorf-Astoria Hotel. This was hardly a major coup, as the show included only nine paintings, but the notices were worthy of the effort, and Russell had his foot in the door.

As Russell continued to develop as a master of mood and poetry, the domestic lives of Indians attracted more of his attention. His watercolor *The Beauty Parlor* possesses an elegant quietude and seductive interplay that at once engages the viewer in romantic reverie. A few years later the *Helena Record* would recognize Joseph Henry Sharp as the "foremost Indian painter in the United States." In the argument to confirm this assertion, the paper maintained that he, as opposed to others who paint the Indians, understood that they had "a home life" and were "not always arrayed in the full panoply of war." Sharp was also celebrated for the ethnological accuracy of his observations. On both counts, however, Russell could be considered his equal, as many of his best paintings have realistic depictions of domestic life as well as artifacts and customs.

Russell had built a log-cabin studio adjacent to his Great Falls home in 1903. He draped the walls with Indian and cowboy gear collected on area reservations and during his range years, and these artifacts were used liberally as props in his paintings, drawings, and sculptures. The interrelationship of these media with the artifacts can be readily observed in the watercolor *The Sun Offering*. The idea

The Beauty Parlor

1907. Watercolor, 8 x 9¾"
Courtesy of the C. M. Russell Museum
Great Falls, Montana

Russell's watercolors could be soft, almost pastel-like in their delicacy, when he was trying to evoke moods of mystery, dreaminess, or sentiment, as is the case in this picture.

Study for *The Sun Offering*

1907. Pencil, 8¾ x 5⅛"
Courtesy of the C. M. Russell Museum
Great Falls, Montana

When conceiving a painting, Russell would spend many hours designing the picture in his mind or making wax studies and pencil sketches. This drawing is an especially well-finished study for an illustration that appeared on the cover of Leslie's Weekly, August 8, 1907.

Offering to the Sun Gods

1902. Polychrome wax, height 14½"
Courtesy of the Buffalo Bill Historical Center
Cody, Wyoming

Russell preferred wax to oils and often said he felt more comfortable sculpting than painting. However, since people preferred the latter, Russell, until more than halfway through his career, used sculpture solely for amusement or as preliminary studies for paintings.

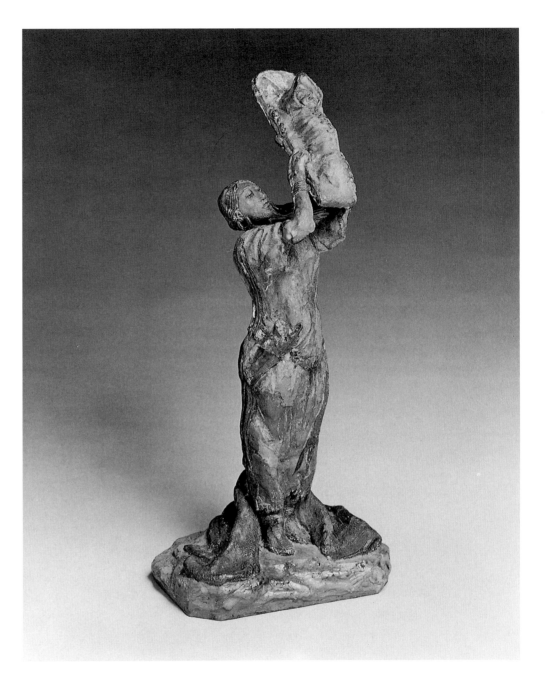

for such a scene, depicting a Blackfoot woman praying to the sun for benefaction toward her baby, probably began with a lump of wax. In 1902 Russell produced a model titled *Offering to the Sun Gods*, and the pose and concept were born. At a somewhat later date, and probably directly before producing the finished watercolor, he drew a compositional study in pencil, in which he recorded generalized and specific ethnographic details. The Blackfoot dress, for example, came right from his studio collection. The only things left to draw were directly outside Russell's studio window—the light of a Montana morning and a touch of landscape.

86

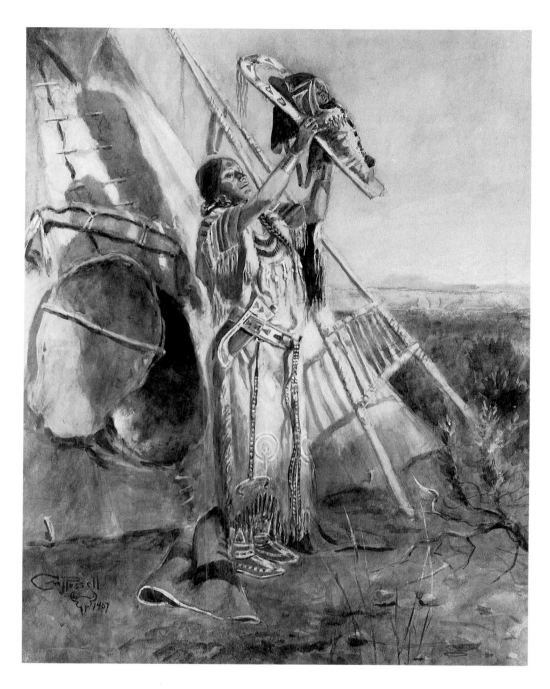

Blackfoot Dress

Courtesy of the C. M. Russell Museum
Great Falls, Montana
Russell Studio Collection

A yoke of blue and white "pony" beads decorates this Blackfoot woman's dress of elk skin, with elk's teeth dangling from the bodice. Russell used such Indian and cowboy apparel and artifacts to adorn figures in his paintings, so that they might be appreciated as authentic as well as emotionally provocative.

Sun Worship in Montana

1907. Gouache, 22½ x 17½"
Amon Carter Museum
Fort Worth, Texas

The studio collection that Russell amassed proved very helpful in his day-to-day efforts at chronicling the West and its people. Accurate depictions of customs and costumes resulted in convincing pictures that earned the artist significant acclaim. The mode of expression and the dawn's glow prove, however, that his inclinations also leaned toward mood, not just accuracy.

Russell's favorite places for recording details of landscape were just outside of town, where he could look west toward the suffused distant buttes or at his summer cabin on Lake McDonald. The summer place, appropriately called Bull Head Lodge, began as a simple log cabin and was eventually expanded with a large porch and sleeping cabin. There he painted from June through September, usually out on the porch in pleasant weather. During the summer months of retreat, Russell began making small plein-air studies in oil. They were visual notes that quickly and sympathetically recorded the nuances of light and color, along with topographical detail and compositional ideas. Intermediate-size oils

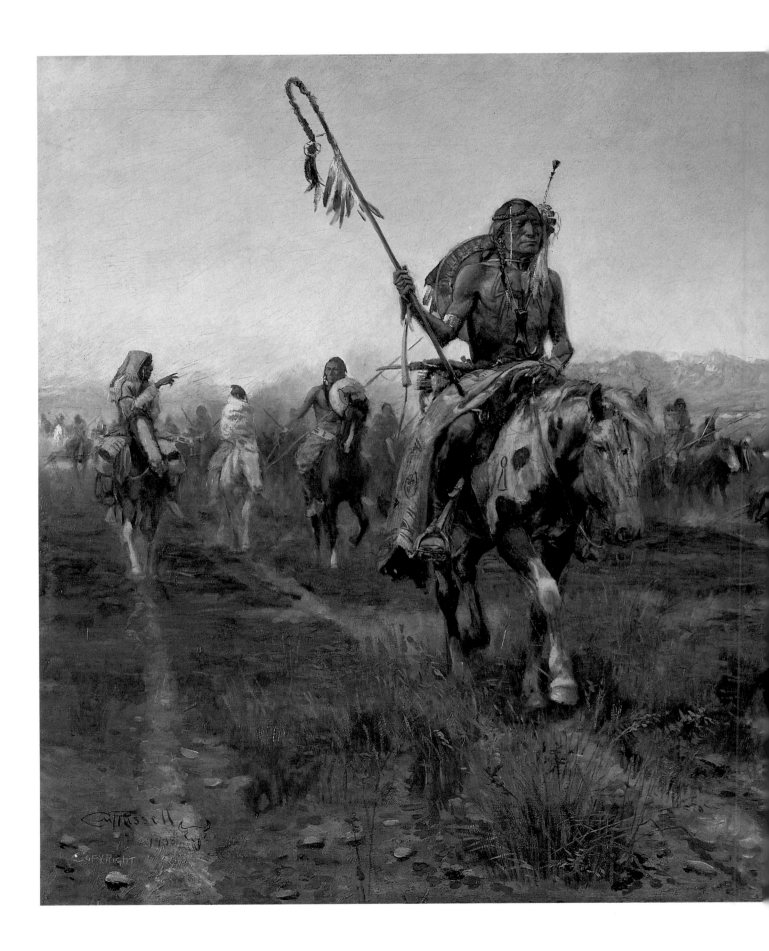

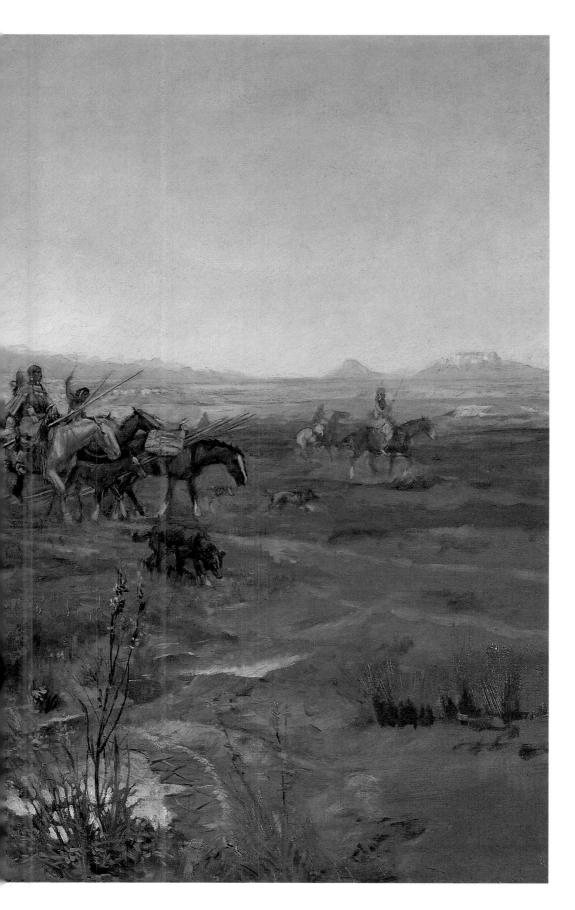

The Medicine Man

1908. Oil on canvas, 30⅛ x 48⅛"
Amon Carter Museum
Fort Worth, Texas

The image of the medicine man leading his people to a new home captivated Russell. Over the years he produced several variations on the theme, including a 1916 rendition that Nancy Russell retained throughout her life.

The Russells began spending summers at Lake McDonald shortly after the turn of the century. Their cabin served as refuge, studio, summer headquarters, and artists' mecca. Most important, it was a place where they could feel close to nature and set their own pace.

and watercolors helped him explore the potential for such finished paintings as *Deer at Lake McDonald*. There, in the quiet and dulcifying north woods, Russell felt most at home with himself and with nature.

However, Bull Head Lodge offered no retreat from his fellow man. He and Nancy shared their summers with family, friends, and fellow artists from across the country. Their guest register for 1906, for example, records no less than thirteen guests, and 1908's lists twenty-two.

The harmony that Russell sought with nature and with the past manifested itself brilliantly in his paintings of this period. *The Medicine Man*, a large important oil of 1908, conveys a mood of nostalgia for the proud native traditions that

UNKNOWN PHOTOGRAPHER
*Charlie and Nancy at Bull Head
Lodge, Their Cabin on Lake
McDonald*

1903.
Courtesy of the C. M. Russell Museum
Great Falls, Montana

the artist enthusiastically endorsed and evocatively preserved. It was initially
shown in a 1909 group exhibition in Helena, along with works by two other re-
nowned Montana painters, the landscapist Ralph De Camp and Sharp. The
powerful compositional force of the central figure is balanced by the parade of
mounted figures behind. The color is strong but subtle, and as one viewer noted,
"the indescribably translucent atmosphere" of Montana is captured here by
Russell as no other artist has "yet even approached." The painting is simple yet
authoritative, and it won critical acclaim from eastern as well as western savants.

Russell was gaining a firm hold on the nation's attentions and affections,
at times to the detriment of his colleagues and contemporaries. In the pre-
Christmas issue of *Collier's*, which for five years had been publishing full- and
double-page color illustrations of Remington's paintings, an article appeared by
Emerson Hough titled "Wild West Faking." It is not known why Remington was
out of favor with Hough, but the writer had certainly tired of his presence on the
western art scene. Remington's career as a painter had risen to the heights, but
Hough saw him as a charlatan who knew nothing of what he painted and
cared less.

Russell, without his own doing, found himself in the middle of the fray
instigated by Hough. And, as Hough told it, Russell was the winner. His paint-
ings were convincing, straightforward, and truthful. He had lived the scenes he
painted, whereas Remington had ostensibly observed them from afar, both

physically and emotionally. No matter that Remington at the time was deeply involved in perceptual concerns in his art, while Russell still focused on conceptual ones. Remington was not believable; Russell was. The public, thirsty for valid, present-tense imagery, took hold of Russell and clasped him to their bosom.

Many Russell aficionados, then and later, took these arguments to mean that Russell was a superior artist because his experiences implied accuracy of depiction. To Russell promoters such as actor and humorist Will Rogers, whom he met in New York at this time, accuracy was equated with purity and artistic honesty. Yet Russell had ceased being a mere recorder of facts, a documentarian, years before when he realized that photography could accomplish that. By the time he started painting seriously, the West was already mostly concept—as Brian Dippie describes, "one part fact, one part myth, and larger than either." Russell, in such paintings as *Bronc to Breakfast, Smoke of a .45*, and *A Serious Predicament*, was not nearly as interested in the correctness of each rowel of the spur as he was in creating the spirit of the West he had known and much of it that he had not. Russell was a realist painter and rarely strayed from the conventions of that school, but this does not imply any more of an allegiance to accuracy than to romanticism. Russell's work enjoys a healthy mix of both.

Smoke of a .45 is especially interesting because of its status as Will Rogers's favorite painting, as well as the fact that its motif became such a fundamental part of Hollywood's later image of the West and the cowboy. Russell, who initially resisted the western movies due to their abhorrent lack of authenticity, eventually became addicted to them. Rogers was his favorite actor because he was "a regular feller," not unlike the cowboys who peopled Russell's canvases.

Deer at Lake McDonald

1908. Oil on canvas, 15 x 20"
Collection of Mr. and Mrs. Lyle S. Woodcock

*After about 1900, Russell spent several
months each year along the shores of Lake
McDonald. He knew the lake's moods and
variations and relished the opportunities
to paint its portrait.*

Bronc to Breakfast

Bronc to Breakfast is particularly significant because of its dramatic highlighting of the two most unique elements of Russell's art during this period—his astute exploitation of humor through irony and his ability to see around form and relate three-dimensionally on a flat canvas surface. Lauding these attributes, Gutzon Borglum wrote: "Russell had not only the wit to see the dual situation attached to any great moment, but he had, and with an ability Remington had never shown, the power to draw animals, horses, cattlemen in the mixed-up, tangled-up situations daily occurring in the wild unfenced West—situations no other artist has ever attempted."

In accomplishing the most successful of these works, Russell often depended directly on sculptural compositions he had already resolved. This was the case for his consummate drama on canvas, *When Blackfeet and Sioux Meet*, which relies heavily on his 1905 bronze *Counting Coup*. The centricity and unity of the composition, the individual figural poses, and the narrative tension had all been worked out in wax and bronze prior to the production of this masterful canvas. This deviated somewhat from his usual practice of conceiving a painting, then modeling the figures for it in wax, and ultimately painting from the wax figures.

Russell made many more wax models than he ever had cast, or even intended to have cast, in bronze. His predilection for sculpture was born of a natural talent. As Russell scholar Ginger Renner has observed, his modeling of wax figurines was so facile that it suggested "almost sleight of hand." Reputedly, he always carried in his pocket a lump of modeling materials—a mixture of beeswax and tallow—and could fashion a familiar animal or human form virtually without looking. Generally, though, he enjoyed allowing onlookers to watch a wax figurine take shape through the effortless, nimble dexterity of his slender fingers.

Once modeled, most of his waxes were again wadded into a ball for the artist's further diversion or the amusement of onlookers. Occasionally a figure was retained and left to harden. Russell traditionally painted these figures and, when appropriate, would add cloth garments or hair, grass or wooden supports. Numerous subjects in wax, or even wood, plaster, and baked clay, remain as testament to Russell's versatility and creative responsiveness to this medium.

Most accounts of Russell's working methods assert that he never used live models. According to a typical reference, "He makes his little clay models of horses and men for the pictures he paints. He never has had any person or living thing pose for him." Russell himself stressed that "a human model would have a hell of a time posin' for me. . . . I'd have to spike him to a wall. . . . I get along all right with mud." However, a good deal of evidence to the contrary remains, including photographs from his personal collection picturing models posing in his studio. There are also references to specific models, such as his friend Young Boy, a Cree whom he met in the Judith Basin in the 1880s, and Con Price, who may have posed for Big Nose George in various holdup scenes. Russell also modeled for himself, twisting his body before a mirror. But it was easier with a live model, preferably one who understood the problems of painting action-filled canvases. In May of 1908 he invited his friend the New York illustrator Philip

Bronc to Breakfast

1908. Watercolor, 19 x 25¼"
Mackay Collection, Montana Historical Society
Helena, Montana

Russell enjoyed cooking over a campfire or in the fireplace of his studio. He especially liked to do this for company, and his meals and desserts were acknowledged as good fare. It must have been out of sympathy for the old camp cooks that he developed his many interpretations of spoiled breakfasts on the range.

Smoke of a .45

1908. Oil on canvas, 24⅜ x 36¼"
Amon Carter Museum
Fort Worth, Texas

The unbridled lawlessness of early Montana is represented here. Given the dramatic subject, it is no wonder that this painting was a hit with the Hollywood crowd, especially Will Rogers, who called it his favorite.

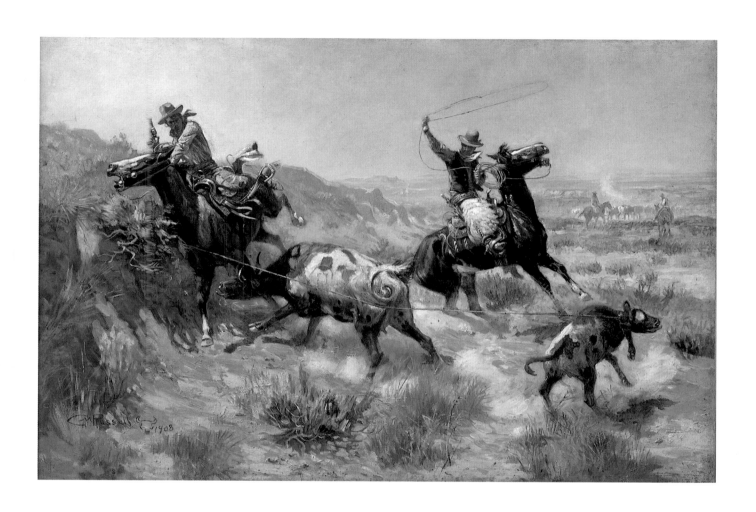

A Serious Predicament

1908. Oil on canvas, 20 x 30"
Private collection

Russell's action paintings swell with elements of tension and danger pulling against one another at full force. Yet even with the explosive potential of an eruptive scene like this, there is usually an intervening participant who may prevent disaster from occurring.

Goodwin to visit Nancy and him at Lake McDonald that summer. It would be nice to have another artist around to paint with and to talk of common interests. Also incorporated in the invitation was the notion that "we could pose for one another when we get stuck."

Russell wanted Goodwin to help him resolve the problem of a group of buffalo he was painting at the time. Goodwin's reputation was solidly acknowledged in animal painting, and Russell longed for a sympathetic eye and welcome counsel. Goodwin accepted Russell's invitation, and the two worked side by side and shared much. A few years earlier, after Russell had returned from his second trip to New York, the *Butte Evening News* made an urgent apology for Montana's cowboy artist getting so close to other artistic sources. "No tutor of Paris or Venice or Berlin bequeathed learning to Russell and smoothed his path to knowledge," it clamored. "He cut his way to art through the rock-bound obstacles of personal experience . . . he was taught nothing." But such defensive provincialism neither benefited Russell's image nor enhanced an understanding of his art. Russell did not live in a vacuum but was rather very open to the exchange of ideas.

Aesthetic inspiration and technical advice flowed both ways. Russell's influence on the younger Great Falls painter Olaf Seltzer has long been acknowledged. He encouraged Seltzer to try painting in oils and indirectly guided the direction of his work as early as 1890. That Seltzer's first oil and many later ones looked surprisingly like Russell's only flattered the mentor.

Sometimes the influence went beyond mere style and technique. Russell's presence was so pervasive for Edward Borein that his whole career was altered as a result of their association. In 1908, after laboring several years at trying to perfect his work in oils, Borein abandoned the medium, using as his excuse the speculation that he would never be able to equal Russell's skills. He turned to etching instead.

Both Goodwin and his contemporary Herbert Dunton liberally employed Russell's compositional device of one group stalking another, an enemy or prey, from behind a rock, as seen in *Plunder on the Horizon.* It was a composition that Russell had learned from Wimar, so he was comfortable passing it on to a third generation. Dunton's early paintings of bucking broncos also owe much to Russell's examples.

Russell, at the end of the decade and after twenty years of serious painting, was still finding uses for the Düsseldorfian conventions that Wimar had brought back to Saint Louis in 1856. In *Bringing Home the Spoils* of 1909, Russell showed them off to great advantage. Two trees, one in the right foreground and the other in the distance on the left, frame the scene, as the side curtains might a stage. The prominent figure moves forward on that stage and is silhouetted by a strong flood of back light. Although there is no physical action, a sense of anticipation fills the air, and a dramatic narrative unfolds for the viewer's imagination to embellish. As the rider moves forward into space, Russell's audience is drawn back into time, possessed by the mystery and captivation of history. They are at one with Russell and his expression.

Bringing Home the Spoils

1909. Oil on canvas, 15⅛ x 27¼"
Courtesy of the Buffalo Bill Historical Center
Cody, Wyoming

This warrior, proudly attired in his split-horn bonnet, brings back rich bounty from a horse raid. Horses were a symbol of status among Plains Indian men, and this fellow was due some extraordinary recognition.

NO "WILD WEST FAKING"

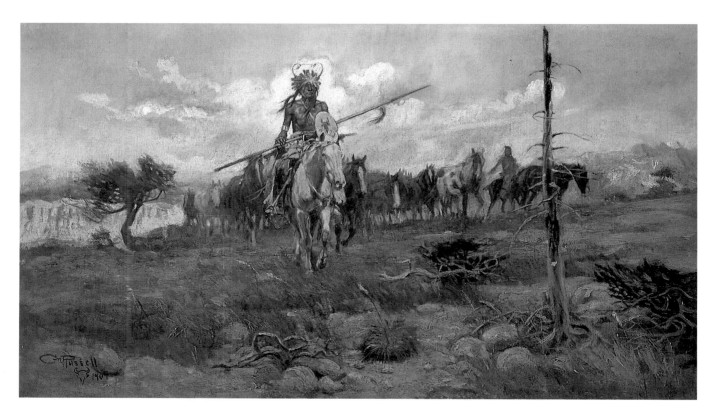

Bringing Home the Spoils

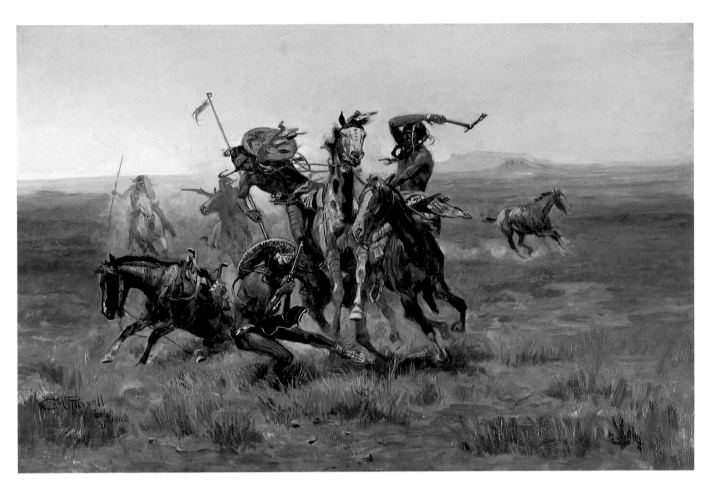

When Blackfeet and Sioux Meet

V. "The West that Has Passed"

He paints the West that has passed from an intimate personal knowledge of it; for he was there in the midst of it all, and he has the tang of its spirit in his blood. He has recorded something of the earlier days in the life of that country, of its people, of their curious ways and occupations, a life that has practically passed; for civilization has come, and before civilization, the elemental passes away, swallowed up in certain conventions that are rightly deemed necessary for the development of a new country.

Arthur Hoeber
The World's Work (1911)

THE TRIUMPHS OF RUSSELL'S EARLY artistic life had included his first Saint Louis commission from William Niedringhaus, the World's Fair exposure, and his several one-man shows there in the first years of the century. As the decade ended, Niedringhaus again stepped in, this time to close that chapter. In 1910 he assembled a large group of Russell's oils and watercolors for an exhibition in Saint Louis under the title "Paintings by C. M. Russell," apparently loaning some works from his personal collection and borrowing others from friends and relatives. A good many must have been consigned by the artist, including *Smoke of a .45* and *When Blackfeet and Sioux Meet.* Some had price tags on them. It was a hometown swan song, a bon voyage, for Russell was about to become famous from coast to coast and even internationally.

Certainly he was ready to break out of the mold, if there was one. His financial security appeared sound, since Nancy in 1908 had renegotiated his Brown and Bigelow contract for a guaranteed annual income of three thousand dollars for work used on their calendars. In addition, she had insisted on healthy prices (Charlie considered them outlandish) for his art. In the 1910 exhibition in Saint Louis, for example, *Smoke of a .45* was listed for one thousand dollars and its companion piece, *In without Knocking* (1908, Amon Carter Museum), for nine hundred dollars. The time was ripe to move ahead. Nancy seems to have led the way, with Charlie working to fill the orders. They were both doing a brilliant job, Nancy marketing and Charlie living up to her every boast and expectation.

Of course the way to keep that momentum going was to produce big work with powerful imagery and universal appeal. Russell complied full force with

When Blackfeet and Sioux Meet

1908. Oil on canvas, 20⅛ x 29⅞"
Courtesy Sid Richardson Collection
of Western Art
Fort Worth, Texas

Tales of valiant deeds among Indian warriors filled American literature beginning in the early nineteenth century. However, Russell accumulated information for this painting not from books but from direct association with an Indian informant.

101

such paintings as *In the Wake of the Buffalo Runners*. Although he had explored the theme many times before, this latest effort evinced an epic quality, as if Russell were implying more than simple traditional native values. The young woman, surrounded by two generations of family and scanning the horizon for tomorrow's home, evoked a strong message. Perhaps this heroine was the true American Madonna—the leader of her people, the harbinger of peace, and the exemplar of grace. He never took such notions to the extremes embraced by some of his young friends of the Howard Pyle persuasion, who would apply Pre-Raphaelite principles to their western illustrations. But he did overtly exalt the status of Indian women and idealize their place in the scheme of Indian life.

In April, 1911, the Russells returned to New York for the opening of Charlie's first major one-man exhibition at Folsom Galleries. Appropriately titled "The West that Has Passed," it brought him into the limelight as never before. The art critic Arthur Hoeber commented that Russell was still more an illustrator than a painter and that his work remained a bit uneven, and Russell heartily agreed with both remarks. But Hoeber also put the Montana artist in his proper place, observing that "he is full of enthusiasm for the country which he paints, and since the death of Frederic Remington [December, 1909], he is almost without a competitor." Hoeber concluded that "among men artistically endowed," Russell was now "the official historian of the West that has passed."

Russell was not one to set himself above others, but he accepted the accolades and, with Nancy's encouragement and hard work, embarked on a spate of exhibitions over the next several years, from Chicago and New York to San Francisco and, internationally, Winnipeg, Calgary, and eventually London. His most immediate successes, however, occurred right at home in Montana. In July, 1911, he was awarded a commission to paint a mural for the wall behind the speaker's station in the Montana State House of Representatives. It had been a tough battle to win the contract, primarily due to competition from more established muralists, specifically John Alexander of New York. But Russell convinced the selection committee that he was the right man for the job.

The task presented substantial challenges for Russell. As he pondered them one day, he wrote to Goodwin: "I got the job of the capital an as the picture is only 25 feet long an 12 wide its got me thinking some the subject is to be Lewis and Clark meeting the flat heds this is some jump for me an I am liabel to have to call for help send for all my New York friends an put them to worke." Russell never lived up to the threat, mostly because he learned, after writing Goodwin, that the painting could be done on canvas rather than with traditional plaster techniques. He was thus able to accomplish the task in his studio, after some modifications in the ceiling were made and after he had traveled to the site of the historic encounter to make color and landscape studies.

A year later, and on schedule, the mural was installed. *Lewis and Clark Meeting the Flathead Indians at Ross' Hole* was the title Russell gave it, and the critics gauged it "his best and most finished product." Subsequent authorities such as Harold McCracken hailed the work as Russell's masterpiece. The artist had used

In the Wake of the Buffalo Runners

1911. Oil on canvas, 29½ x 35½"
Private collection

Russell painted some scenes of Indian life that evoke an almost Christian iconography. In this work the Madonna figure leads her people to a new land. She embodies the virtues of motherhood—elegance, grace, resolve, and beauty.

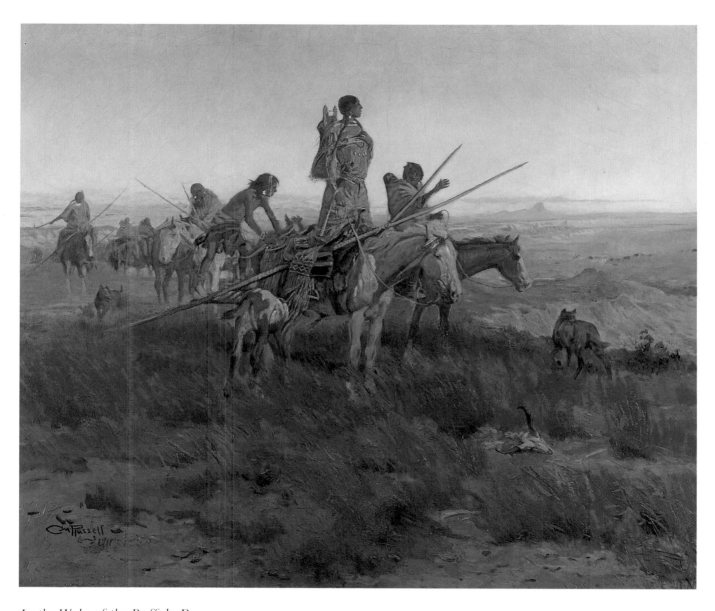

In the Wake of the Buffalo Runners

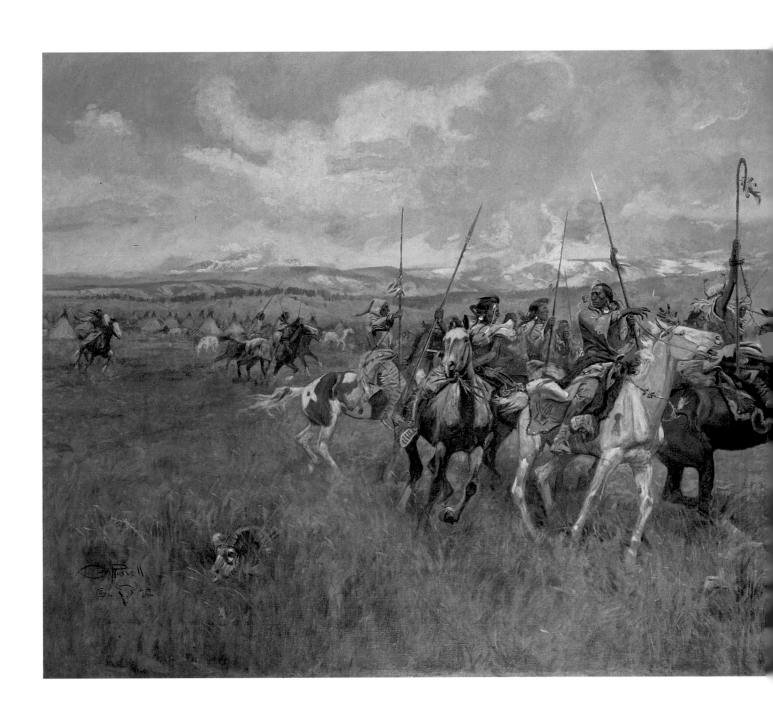

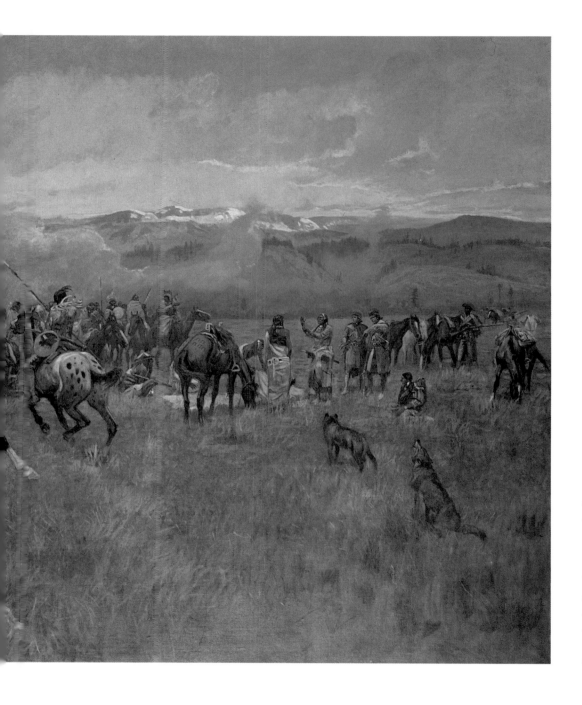

*Lewis and Clark Meeting the
Flathead Indians at Ross' Hole*

1912. Oil on canvas, 12 x 25'
Montana Historical Society
Helena, Montana

*The grandest work of Russell's career is
this heroic presentation of arms. In its epic
scale, the painting is comparable to
Meissonier's visions of the Napoleonic
Wars, but focused on a strictly American
historical theme and setting.*

the subject is to be Lewis and Clark meeting the flat heds

this is some jump for me an I am liabel to have to call for help send for all my New York friends an put them to worke Pike Webster was down befor Christmas an stayed about two weeks an had a good time he often spoke of you I got an invitation not long ago from Emerson Hough an a friend of his that owns some trading posts up north on the Mc Kinsey river to go with them to the Arctic sea an I think I will go we start from Fort Edmonton

Letter from Charles M. Russell to Phil Goodwin (page 2 of 3)

January 26, 1912. Pen, ink, and watercolor
Stark Museum of Art
Orange, Texas

When Russell signed a contract with the State of Montana to create a mural for the House of Representatives, he had no idea what it would entail technically. The narrative would be no problem for him, but the scale and medium were untested. Fortunately the finished project was approved as a large canvas requiring no plaster and scaffolds, as pictured in this letter from Russell to fellow artist Philip Goodwin.

Deer Grazing

1912. Oil on board, 11 x 17⅞″
Courtesy of the Buffalo Bill Historical Center
Cody, Wyoming

Veils of clouds enshrouding precipitous mountain peaks show Russell's symbolic recognition that nature's mysteries cannot be totally revealed. In the same manner he also celebrated the harmonies within nature in its purest state.

his strongest compositional treatment, the inverted pyramid. True to his conviction that the Indians were the paramount force in early western history, the scene focuses on a swirl of mounted warriors, with the actual greeting of the Anglo explorers quite secondary. The low horizon line gave Russell a chance to concentrate the action as well as to celebrate the beauty of a Montana sky at dusk.

Those enduring and poetic elements of the West became increasingly attractive to Russell as subjects for his art. Certainly he enjoyed recounting the drama and surge of human activity—the cowboy and his steer or the Indian and his buffalo—but the universal, unchanging aspects of nature were also reassuring to him. The human chapters might close and become part of history and remembrance; a mountain park was timeless. Paintings such as *Deer Grazing* and sculptures such as *Buffalo Family* testify to the reverence Russell felt for nature's riches

Deer Grazing

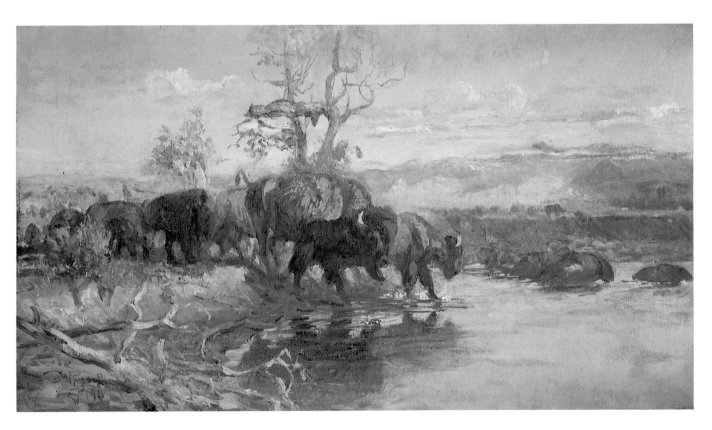

His Heart Sleeps

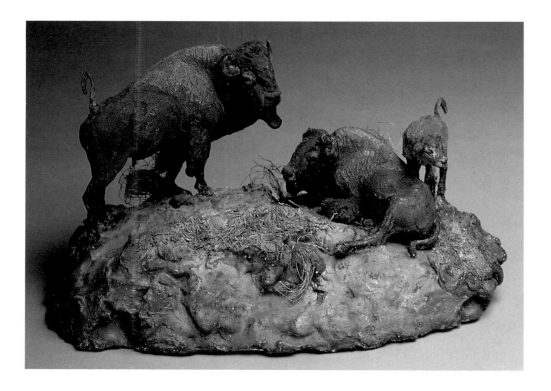

Buffalo Family

c. 1910. Polychrome wax and plaster, height 5½"
Courtesy of the Buffalo Bill Historical Center
Cody, Wyoming

Small waxes such as this were not modeled as future bronzes, but rather as figure and compositional studies for paintings. Nonetheless, they were painstakingly finished.

and the skill with which he handled its symbols. The mountains offered humility, autumn colors suggested fulfillment, and the deer taught contentment.

More obviously metaphorical work, such as *His Heart Sleeps*, manifested his dream of continuity. While the burial scaffold cradled in the tree's branches represents loss and quiescence, the buffalo pouring forth from the prairies into the river offer a sense of hope for a future possibly replenished by the resources of the past. It was all in nature's hands, right where, in Russell's mind, it should have always stayed. His lament was nowhere more clearly stated than in these paintings of wildlife, of nature in her many glories.

When man now intruded on this scene in Russell's art, he was more than likely stepping lightly onto the land, the soles of his shoes soft and the core of his spirit in tune with the elements. In order to achieve such statements, Russell worked hard at selecting empathetic characters to fill his paintings and at harmonizing colors, so that the overall effect might impart a sense of unity. These goals were most fully achieved up to that point in his painting *Carson's Men*. The suffused opalescent glow, the brilliant bands of gold, the voiceless communication of men, and the cushioned silence of the horses' steps in the sand answered Russell's quest for unifying pictorial elements.

A few years later, when Russell was called upon to produce a consummate statement about his beloved West, he chose a subject that left man entirely out of the picture. The Montana Club of Helena had, for a number of years, been collecting representative examples of art related to the state. In 1913 the members commissioned a large piece from Russell, which was delivered in early 1914.

According to Frank Linderman, a friend of Russell's who helped secure the commission, the painting proved to be difficult for the artist. Evidently the central figure, a large buffalo bull, caused most of Russell's anguish. He made pencil

His Heart Sleeps

1911. Oil on canvas, 6⅞ x 11⅞"
Courtesy of the Buffalo Bill Historical Center
Cody, Wyoming

In Russell's ideal world of the Indian, death was simply part of a larger cycle of life, whose songs and rhythms move on continually just as surely as the great rivers flow and the sun rises.

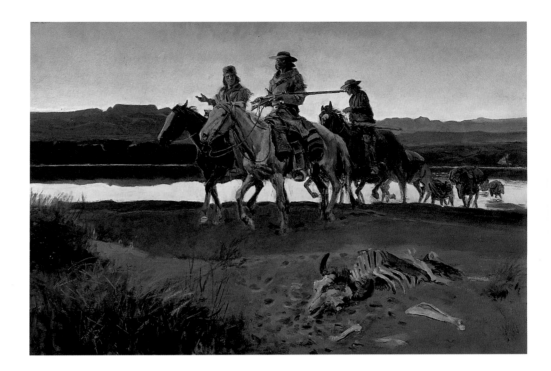

and oil, as well as wax studies for the painting. Even so, as Linderman recounted, delivery of the painting was delayed several months because of the problems Russell experienced with that figure. Once the work arrived in Helena, however, and was installed in the club's reading room, all observers agreed that it was Russell's best, even surpassing the mural, according to the members. Russell had been through a struggle, and his dyspeptic expression as he posed next to the finished work is convincing evidence of the battle. Yet he was pleased and gratified and gave the painting the title *When the Land Belonged to God*.

About a month after the men at the Montana Club received their magnificent gift to themselves, the ladies of the Great Falls Women's Club enjoyed a similar, if somewhat more ephemeral, treat in the form of a special afternoon program on art. Mrs. Conner spoke on "How to See Pictures," discoursing on the styles of painters from Cimabue to Whistler. Then Mrs. Hamilton took over, providing an eloquent analysis of Rembrandt's *Night Watch*. The highlight of the program, however, was Nancy Russell's presentation on her husband's life and art. Some of her commentary was especially revealing about the artist and his working methods. She began by observing that "no man can be a painter without imagination. He must live in his picture." Then she explained further:

> *In the old days men did not read much but were all good story tellers and many of their lives would have made a romance. Although Mr. Russell is a good story teller he is also a good listener and has a remarkable memory for detail. The stories he heard were history that has never been written and would have been lost had he lacked the ability to put them on canvas. People have said, "Where do you get all your ideas? I should think you would run out of them." With him that is impossible, as his great teacher, Nature, and a*

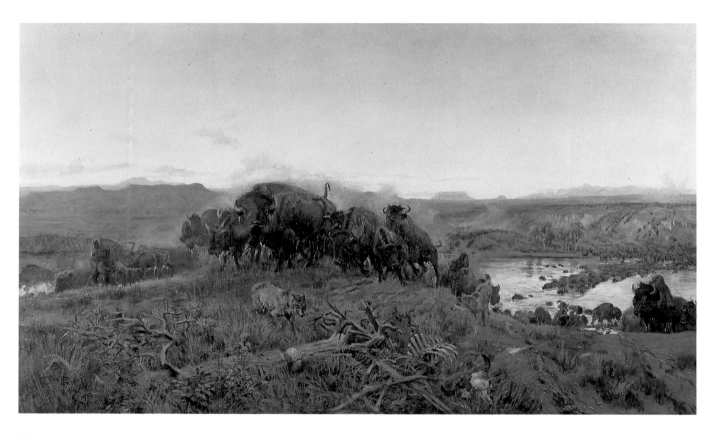

When the Land Belonged to God

few silent men developed and strengthened an already wonderful imagination until now there will be days when he lives in that past that was loved and understood when a boy, and there is no limit to the number of pictures he sees in his world. If he lived hundreds of years he would still be unable to paint them all. . . .

Mr. Russell lives in the past as you all know, and when civilization crowds too close and it is not the season to go to the mountains he takes his coat and hat, his tooth brush in his pocket and goes to Mr. Matheson's ranch near Belt, where the Highwood mountains loom up big and the Belt range make wonderful pictures in the evening sun. At this ranch the artist is a boy, he cooks anything fancy brings to mind or at least he tries, from cake to roasting a chicken, which, by the way, he said was pretty good. When the dishes are washed he will, in nice weather, climb a hay stack and from that elevated place imagine that stretch of country back before the white man came, with Indians and their land alive with game. He goes into what his red brothers would call "The Great Silence" where nature teaches her child. When he comes back from one of these visits I have seen him start three big pictures within one week. When laying in a composition as a rule Mr. Russell is very silent, he will sit evening after evening with a pencil and scratch pad, working out an idea and scarcely talk at all.

The pressures on Russell must have been considerable. Not only was he popular at home but he was also in great demand by authors and publishers nationwide. One book alone, *Fifteen Thousand Miles by Stage*, in 1911, required eighty-five illustrations, including four in color, thirteen black-and-white halftones, and thirty-eight line drawings. The author of the book, Carrie Adell Strahorn, was so persistent that she literally camped out on Russell's doorstep to see that the job was completed to her expectations.

His friend Linderman was more reasonable. When he called on Russell, the artist delivered to the best of his abilities. The illustrations for Linderman, who styled himself an interpreter of Indian lore, are sympathetic and poetic, just as

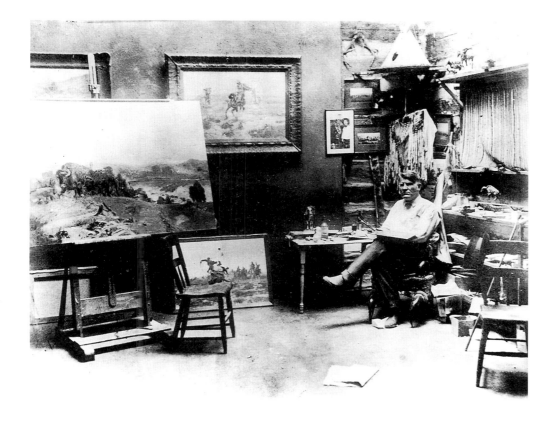

UNKNOWN PHOTOGRAPHER
Charlie in His Studio

1914
Courtesy of the C. M. Russell Museum
Great Falls, Montana

Russell's pride and persistence are re-
vealed in this studio portrait. He had
fought the picture, When the Land Be-
longed to God, *for many months and*
was now relieved, if still somewhat taci-
turn, as he sat near the completed work.

Linderman's tales are. Russell's cover illustration for Linderman's *Indian Why Stories* depicts War Eagle, a solemn and dedicated old warrior who, of an evening and with the proper crowd of young listeners, passes down the verbal traditions of his people to the next generation. Russell and Linderman were both raconteurs, both understanding that gesture and expression were critical to laying a plot properly before an eager audience. They were also versed in sign language and Indian symbolism. Russell made annual pilgrimages to the Montana reservations to brush up on his techniques and refresh his imagery. In Russell's illustration these elements are combined with a wash of golden reverie and noble elegance befitting the story's subject.

Russell was somehow able to fulfill requests for illustrations while still performing on an international exhibition circuit. In 1914 "The West that Has Passed" opened at the Dore Galleries in London, and the Russells were there for the champagne. It was all part of Nancy's master plan, which had begun with an exhibition of Charlie's work at the Calgary Stampede in 1912, followed by a show in Winnipeg the next year. These shows brought Russell's work to the attention of an English clientele who in turn had encouraged the sponsors in London. The Britons, according to headlines in the Great Falls papers, were "Enraptured by Russell's Art." They had never seen the likes of such horses and action and were eager for such visualization of the frontier.

Even the Prince of Wales, who later met Russell in Saskatoon, Canada, acquired one of the Montana artist's provocative canvases, *When Law Dulls the Edge of Chance*. Seeing His Majesty's Mounties serving the cause of justice was just too

Man could learn much from nature, and the Indian, as a child of nature in Russell's eyes, was closest to those lessons. Man and beast were equal partners in that pristine pedagogy unsullied by formalist doctrines of civilized society.

Russell and Frank Linderman shared a fascination for Indian stories and religious traditions. Just as Russell perceived his role as one of pictorial narrator for frontier America, he celebrated those many unnamed Indians who provided historical continuity for their people.

much to resist. Nancy and Charlie must have conspired to produce such appealing subjects for the young prince. At the time of the sale, they actually had three similar subjects from which to choose. Such was their savvy and enterprise.

Russell's exhibition "The West that Has Passed" took many forms over the next several years. As paintings and bronzes were sold by the galleries, new works were substituted, so that at each opening its configuration was different and refreshingly inviting even during a return engagement. When the show was presented for the second time in Chicago, in 1916, there was one particularly exciting oil among the twenty-four paintings and twelve bronzes. Titled *When Shadows Hint Death*, it shows Russell at his best when provoking a dramatic effect. His brilliant narrative capacity may have evolved just as Nancy had described to the Great Falls Women's Club several years earlier. The story was no doubt one Russell had heard around some campfire in the Judith Basin. Its resolution as a pictorial composition was probably achieved of an evening around the dining-room table, one of those silent evenings when the artist was transposing the oral traditions of his youth to the pictorial expressions of his mature artistry. The initial sketch merely suggests the finished composition, but it was enough to serve as the genesis for an engaging painting.

Of all the expressions mastered by Russell in the paintings done at the height of his career, the affectionate portrayal of paradox was perhaps dominant. The situations generally involve man, the solo hunter or trapper, faced

The Storyteller

with the unexpected quirks of nature. The characters in these humorous dramas are presented with an immediate and perplexing decision—whether to confront nature and risk losing everything or to concede, leaving bounty and human needs aside as an admission of nature's victory. The scenes are never resolved in the paintings but rather left to the viewers to place their own morality and values on the determination of destiny. The viewers' conclusions did not really matter to Russell. He had had his chance to raise the question, and much of his own spiritual fiber was rendered just in the asking. Where, for example, is Russell's sympathy in *Whose Meat?* or *Meat's Not Meat Till It's in the Pan?* Is man out of his element or is he challenged, mind and body, to conclude these scenes with a dominant confidence? Those who knew Russell would have bet that he sided with nature. But then, throughout Russell's life, nature had lost, and he had dedicated more than common effort to its lament. Even today, the question is mute and only valid in having been posed.

Because Russell invited friendships so openly, many came to know him well. Those who were close to him often went out of their way to expound on his virtues. In 1917 his friend Philip Goodwin did so at great length for a writer in *Recreation* magazine. His comments provide a good understanding of Charlie from a perspective other than Nancy's. Much of it corroborates her story.

> *He has the true old-time plainsman's and trapper's gift at spinning yarns, and his equal as an original camp-fire raconteur will rarely be heard. He is decidedly human, with a very keen sense of humor and daring imagination, is naturally droll, has perfect control of his remarkably striking features, has a pleasingly mellow bass voice, excellent power of description and tells a story as a gambler plays poker.*

These are helpful and insightful observations, but the person who really knew Charlie, who through his association provided the most revealing view of the man and the artist, was Joe DeYong. The two met in 1914, and Joe became an apprentice artist and something of a member of the Russell family after 1917. He lived with them and worked at Russell's side in the studio off and on for the last ten years of the artist's life. DeYong never achieved much success in his chosen field of painting. As a sidekick of Charlie's, however, he provided immensely valuable companionship and a fascinating record. Joe was deaf, so the two communicated in sign language, at which they were both known to be proficient, or through an exchange of verbal interrogatories by Joe and scribbled replies from Charlie. Many of these written responses are extant today in the collections of the National Cowboy Hall of Fame and the C. M. Russell Museum. Although one-sided, they speak to the daily activity in Russell's studio and his thoughts on art.

For example, Russell is known to have had two or three canvases in process at any one time. However, only through a note to Joe is his working method on each canvas revealed. "I think its better to work all over your picture—not finish one figer and then another it rests you." Replies to Joe's questions also reveal Russell's affection for Catlin and Wimar and his true feelings about his New York cronies such as Goodwin or Dunton, who, without models, were "lost" or who got

When the Law Dulls the Edge of Chance

1915. Oil on canvas, 29½ x 47½"
Courtesy of the Buffalo Bill Historical Center
Cody, Wyoming

This painting, presented to the Prince of Wales by the town of High River, Alberta, Canada, was one of several works produced by Russell in recognition of the Royal Canadian Mounted Police.

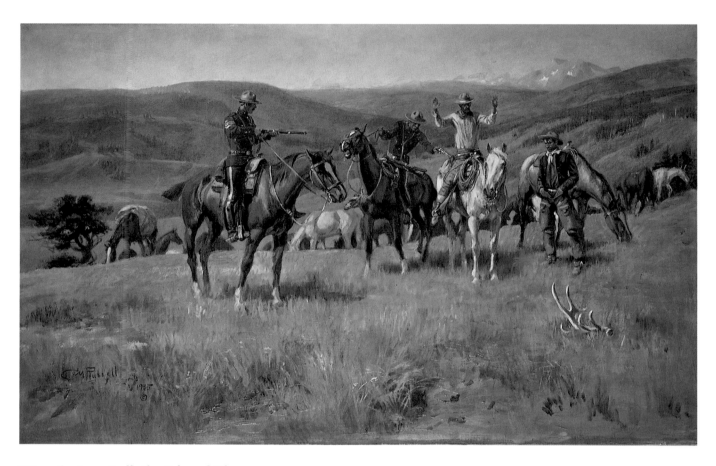

When the Law Dulls the Edge of Chance

When Shadows Hint Death

better once they "quit borrow[ing] of Remington." Joe also made notes about Russell's use of color, his inclinations toward pattern, and his choice of compositions. On Russell's color, for example, DeYong summarized: "stubborn, endless—experiment, continually struggling to match the colors available with those effects repeatedly seen in nature."

Russell's painting *Watching for Wagons* must have been the result of such experimentation. The strong golden light raking in from the left highlights the two prominent figures in the strong but lopsided composition. They focus on abstract shapes in the distance. The glaring light and restless pose of the horses and the young warrior animate the scene, portending a future that the older man, static and propped up by his spear, may not live long enough to know or suffer its tragic consequence.

On his regular visits to neighboring Indian reservations, Russell usually traveled with Nancy, but occasionally with a friend like Frank Linderman. He often carried a camera and photographed gatherings of Indian leaders and old-timers, drawn to them just as he was to timeworn cowboys. He came away from the reservations inspired to preserve their historic past, tinted only with the fresh color and memories of his recent visit. *Piegans* may have resulted from such a sojourn. It is a splendid record of long-gone days when the language of men and nature was, by common understanding, unspoken—only sign and gesture.

Some of Russell's patrons were not content with quiet reflections of past no-

When Shadows Hint Death

1915. Oil on canvas, 30 x 40"
The Duquesne Club
Pittsburgh, Pennsylvania

Russell claimed that one of his most vigorous markets was Pittsburgh, where people had enough money to afford his work and sympathized with his subjects and style. This painting ended up in the city's premier men's gathering place, the Duquesne Club.

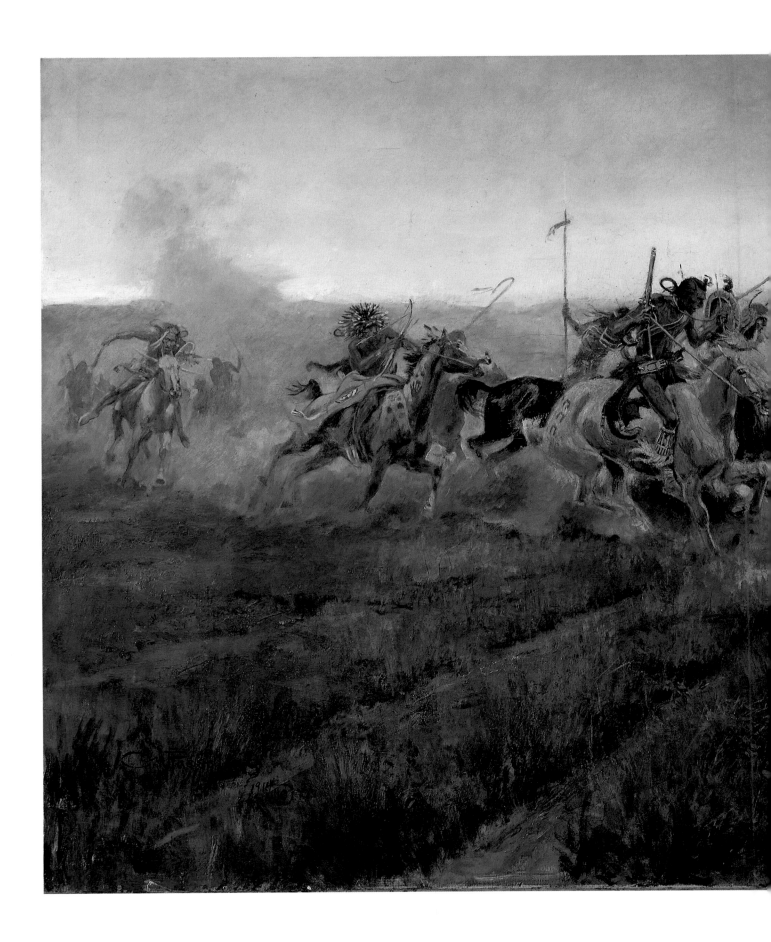

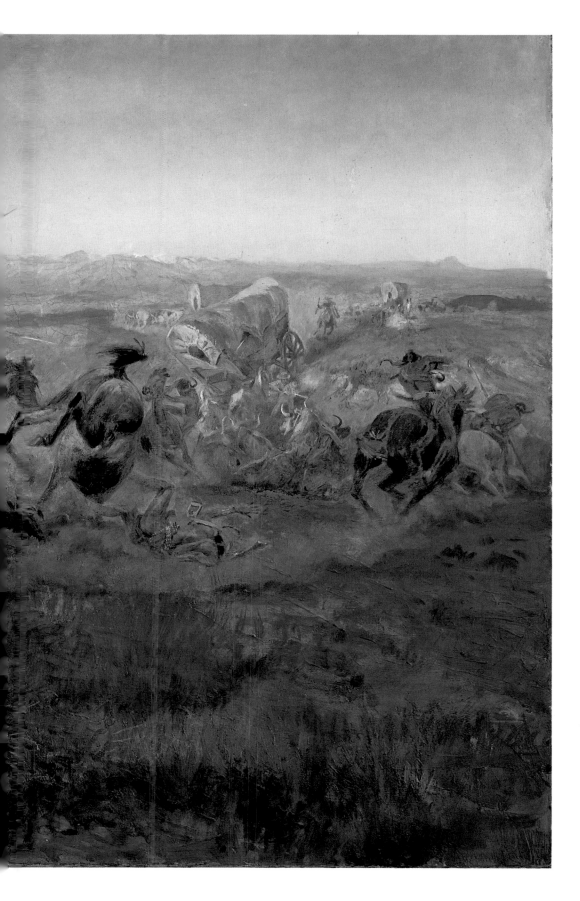

Jumped

1914. Oil on canvas, 30⅛ x 48¼"
Amon Carter Museum
Fort Worth, Texas

Unlike most mid-nineteenth-century artists, Russell generally worked from the Indians' point of view. **Jumped** *shows this perspective, as a group of warriors intercept a whiskey train headed south from Canada.*

Meat's Not Meat Till It's in the Pan

1915. Oil on canvas, 23 x 35″
The Thomas Gilcrease Institute
of American History and Art
Tulsa, Oklahoma

Nature often confronted man with head-scratching perplexity in Russell's paintings. The foibles of man and the confounding of nature formed the basis of the artist's humor.

Whose Meat?

1914. Oil on canvas, 30¾ x 48⅝"
Museum of Western Art
Denver, Colorado

Russell's landscape studies provided useful material for splendid backdrops in his anecdotal works. In some of his later paintings, such as Whose Meat?, *the landscape shares equal force with the narrative.*

Watching for Wagons

bility enshrouded in a Montana dusk. They wanted what the artist was famous for—action, history, and drama—that "Düsseldorf tableau" menu. Among such patrons was Dr. Philip G. Cole of New York, who commissioned several major pictures, in which he wanted a touch of the Wild West. What better scene than the buffalo hunt of the Grand Duke Alexis and Buffalo Bill, which took place on the Nebraska hills in 1872? The completed painting portrayed Cody as something of a tour guide, pointing out to his guest the best bull and the most advantageous line of attack. The Indians brought along to lend authenticity to the scene performed their task well, providing a vigorous counterbalance to the relatively passive involvement of the great scout.

Although this is a dynamic painting thematically and compositionally, the symbolism figures even more powerfully. Here Cody, the hero of the plains and vanquisher of the wilderness, rounds up a remnant herd for the entertainment of royalty. For a brief moment he brings to life the drama of the past to show it off for a visitor from afar who is willing to pay the tab for the experience. And here, at the behest of an eastern patron, Russell freezes on canvas that superficial re-enactment—the condensation of reality that was mythic, even as it unfolded on the Nebraska prairie.

The implication of this was not lost on Russell. He painted *The Romance Makers* in 1918 and suggested, in the heroic proportions of the rider in front, that perhaps the plainsmen and their ilk were consciously riding into a storybook future. He suggested that they knew they were making history, and as a result sat taller in their saddles, rode harder, and dared more boldly so that they might figure more prominently in the history they were creating. At least Russell painted them as if they foresaw the epic that would envelop a whole nation's conscience—an epic they had told with their lives and to which Charlie Russell would devote his own. It was the West that has passed.

Russell was not interested in the story of the local smelter workers in Great Falls or in the woes of the Montana farmers or miners, but there were some obvious characters with whom he identified—the present-day cowboy and Indian whose ancestors had peopled his beloved era in a form reckoned as pure. By 1919 the scenery and its players had changed. Russell preferred to look past them into bygone times. "Cow folks are scare now," he wrote to George Farr that year. "Most of my old friends either rode for ore owned irons many of them have crossed the big range but they left tracks in history that the farmer cant plow under goode or bad they were regular men and Americas last frontiersmen." But he could not ignore their modern manifestations, which, for the cowboy, took the form of movie actors and rodeo performers. At that time Russell declared himself, at least publicly, as scornful of such contrivances. The movies were too unrealistic and exaggerated, while the rodeos hosted events that no true cowboy would understand or tolerate. "There ain't such a thing as 'bulldogging' a steer on the range," he told a Minneapolis reporter in 1919. "All that started with a fake show. I know line riding and broncho busting. But bulldogging! And all the rest of that stuff. Bunk!"

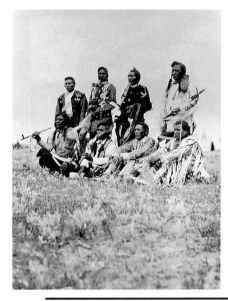

Group of Gros Ventre Leaders

c. 1905.
Colorado Springs Fine Arts Center;
The Helen and Homer E. Britzman Collection
Colorado Springs, Colorado

Russell made annual trips to the Indian reservations to visit and gain new inspiration. Rather than carry a sketchbook, he sometimes went equipped with a camera. This group of Gros Ventre Indians was posing for the photographer Sumner Matison when Russell took this shot.

Watching for Wagons

1917. Oil on canvas, 23½ x 35½"
The Thomas Gilcrease Institute
of American History and Art
Tulsa, Oklahoma

Strongly off-centered compositions and major elements protruding beyond the picture plane are two pictorial devices that Russell may have learned from Oriental art, which he admired.

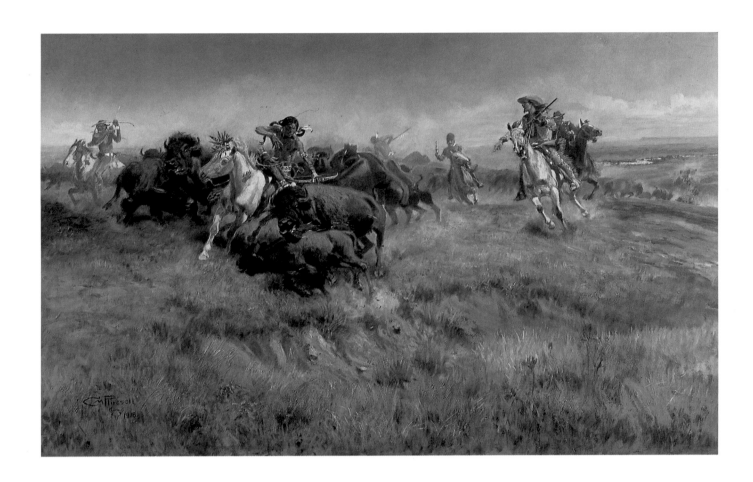

Running Buffalo

1918. Oil on canvas, 29½ x 47½″
The Thomas Gilcrease Institute
of American History and Art
Tulsa, Oklahoma

*Buffalo Bill died in 1917. In his honor,
Russell painted this commissioned work
and another,* Buffalo Bill's Duel with
Yellowhand *(Sid Richardson Foun-
dation).*

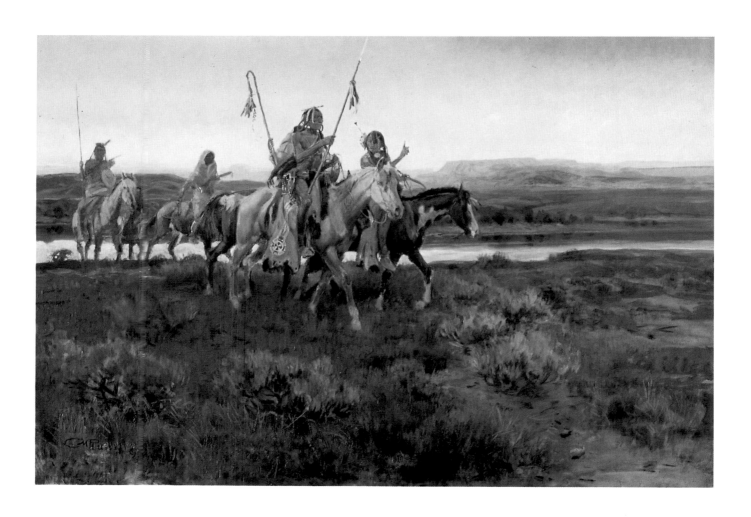

Piegans

1918. Oil on canvas, 24 x 36"
Museum of Western Art
Denver, Colorado

Russell often mixed generations in his paintings, as if to suggest the importance of continuity and the value of traditions. The strength of the family unit gained special significance for him after 1916, when he and Nancy adopted a son, Jack.

However, there was more sympathy in Russell's heart than greeted the newspaperman's ear. He had supported the Calgary Stampede since its beginnings in 1912, and in the same year that he confessed his dissatisfaction with the fabric of rodeo, he and Nancy sent an exhibition of sale works to Calgary valued at more than $100,000 and widely publicized as such. He contributed a sketch for the letterhead of the stampede and produced a number of explosive paintings, such as *A Rodeo Rider Loses*, representing his enthusiasm for the sport. In an expression of affectionate jest, he even put himself in the saddle as a contestant.

Along with Frank Linderman, Russell was a vocal and persuasive advocate of Indian rights. Together the two men helped get the Cree and Chippewa established on the Rocky Boy Reservation in Montana. Although he worked hard to win victory for such social causes, these themes rarely entered his work directly. The reason, he explained, was that his audience was primarily eastern. "If I depended on my home state for commissions and sales," he commented in 1919, "I would starve. In the east they like my pictures." And the easterners were willing to pay the prices Nancy placed on them.

Russell's success in the East, combined with his stated inability to support himself in the West, proved once again symptomatic of the prevailing paradox of the artist's career. When the Russells had guests over for dinner, Charlie would more often than not cook for them out in the log-cabin studio. The fireplace and an old Dutch oven were his tools, and he prided himself on the authentic western fare he had learned to make from Jake Hoover or some range camp cook. But the beans in the pot and the apples for the baked dessert were paid for by the sale of bronzes at Tiffany's or paintings sold at Folsom Galleries to some captain of industry from Pennsylvania or New York. His patrons, for the most part, were peo-

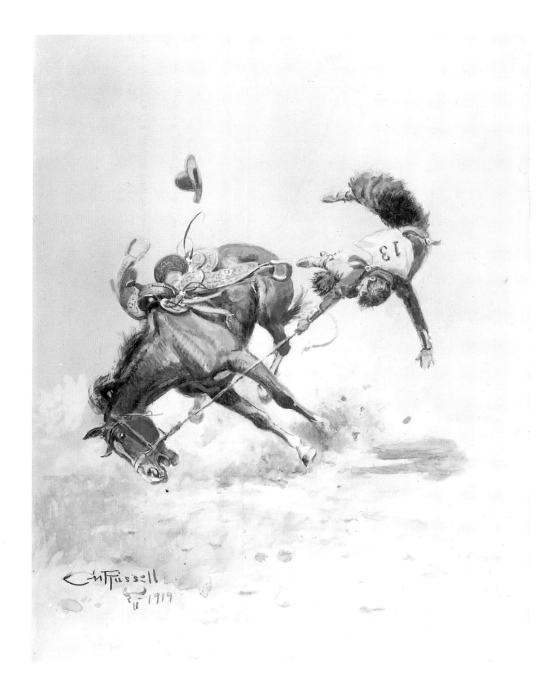

Russell on Bucking Horse

1919. Photo and ink wash collage, 5½ x 5¼"
Courtesy of the Buffalo Bill Historical Center
Cody, Wyoming

When Russell spoofed in his art, he often turned the joke on himself. Usually he portrayed himself as something quite unbelievable, such as a New York dandy or a Blackfoot Indian. This photomontage of the artist on a wild bucker is almost as outlandish.

A Rodeo Rider Loses

1919. Watercolor, 16 x 12½"
From the collection of Earl C. Adams

After several years of associating with the Calgary Stampede and similar enterprises, Russell began to record some of the events, such as bronco riding, in his paintings. Others, such as bulldogging, he denounced as trumped-up "bunk" that did not merit his attention.

ple he did not know or really care to get to know. He confessed to being rather uneasy in the company of easterners. He had escaped into the West as a youth and was now, by virtue of the innocence afforded him in those reclusive haunts, shielded from the implications of his market. Nancy served to insulate him further from those realities, so he could forget, or at least pretend to forget, not only that he was being supported by the bosses of the very civilization he despised, but that he had, in fact, been born into a family that prospered by exploiting the land and promoting expansion.

And what of the images that he purveyed to this enthusiastic clientele? Why were they so popular back beyond the big Missouri? And why did Russell's suc-

Posed Model in CMR Studio

Date unknown
Colorado Springs Fine Arts Center;
The Helen and Homer E. Britzman Collection
Colorado Springs, Colorado

This model was probably photographed by Russell. His fellow Montana painter Joseph Henry Sharp is known to have moved to Taos, New Mexico, partly because models were so difficult to obtain in Montana. Russell may have faced the same dilemma. Although he was able to find some models, he avoided relying on them.

Horse of the Hunter
or *Fresh Meat*

1919. Oil on canvas, 15 x 24"
Williams Family Collection

In 1909 Russell was invited on a buffalo drive. During the chase he was charged by an angry bull and narrowly escaped injury. The experience inspired a number of paintings.

cess with those images in the East undoubtedly depress him so much that eventually, in his later years, associates and family saw a certain hardness and cynicism develop. The images were popular because they were not of the transformation that so agonized the artist but rather of the myth. As historian Robert V. Hine has observed, "Strip the West of its racial ugliness, forget its insistent irresponsibility, and drape the whole in self-reliant individualism, moralizing nature, and fervent nationalism, and America had found its image." What Russell provided for his audience was not the West as it was but rather the West refashioned in his historical mind's eye. His genius therefore centered on an ability to relay the message of nostalgic glorification.

And why did Russell's success produce an eventual bitterness within him? Frustration no doubt came in knowing the truth, of having lived through the years of transformation and having been a part of them. The irony had not been lost on him. It only drove him further into the recesses of the past for a justification of the present. His efforts ultimately resulted in the purging of social guilt and, as such, struck a responsive chord in the collective twentieth-century American imagination. The cathartic note of his pictorial requiem was apparent even as he exercised his most provocative brushstrokes or shaped his most evocative figure.

What he said of his eastern clientele (particularly in Pittsburgh, where he maintained an enthusiastic group of collectors) was that "they may not be so strong on art but they are real men and they like real life." What they liked, of course, was not real life at all but the illusions of past glories as Russell was wont to give them. *Fresh Meat*, painted in 1919, had nothing to do with current Indian issues, aside from Russell's employment of local Indians as models. It called up the triumph of noble horsemen over nature and repeated compositions and themes he had successfully exploited years earlier in *Surround*.

The Minneapolis Institute of Art held a special exhibition of Russell's work in the winter of 1919. The local press suggested that his buffalo-hunt paintings had "historical value" and that *The Romance Makers* profited from the bright theatrical back lighting he favored in the work of Maxfield Parrish, his favorite fellow painter. Yet they concluded that Russell's style must be regarded as strictly individual, separated from all other art movements of the day by "the big simplicity of his nature." He was, as Etelline Bennett had written in the spring of 1919, "painting the old West as it was, for a generation to whom it will be only a tradition." The task was worthy of the lifework of any artist, and Russell proved up to the task.

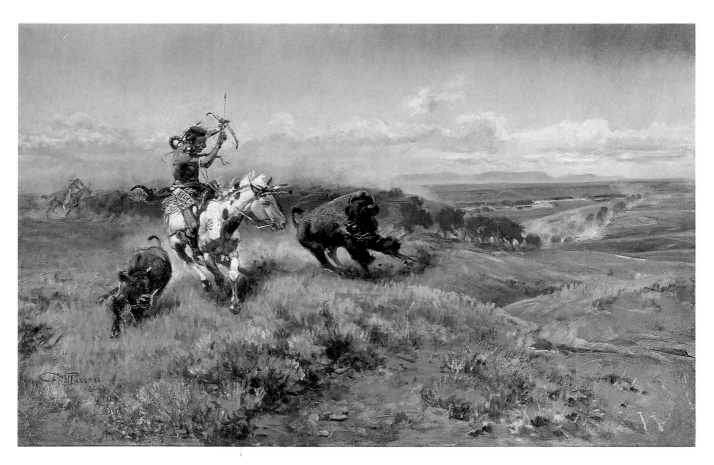

Horse of the Hunter or *Fresh Meat*

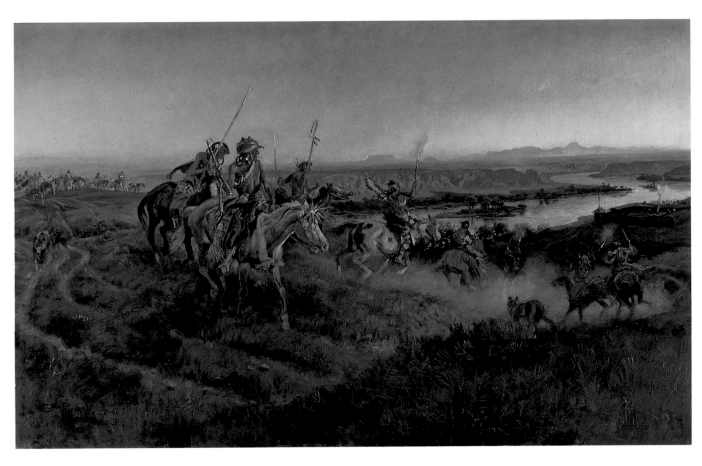

The Salute of the Robe Trade

VI. "But He Left Us Much"

A lot of those birds go west to some dude ranch, or tourist camp, stay three months, and then either write stories or paint pictures of the west and say, "I know, for I have been right over that very country." Charlie says he don't know anything but Montana, and he don't paint anything but Montana.

<div align="right">Will Rogers (1924)</div>

AFTER 1919, THE RUSSELLS SPENT their winters in southern California. The weather was inviting for the most part and, in contrast to Montana, appealed to them as they began to age. The clientele also proved to be a breath of fresh air, and Nancy exploited their wealth with full vigor. Through Charlie's friend Will Rogers they met much of the Hollywood crowd, especially those who acted in the westerns. William S. Hart collected Charlie's work on a significant basis, as did Rogers himself. The Russells also rubbed shoulders with some of the non-western crowd in and out of the actors' guild. Douglas Fairbanks, Sr., for example, so impressed Charlie that he sculpted a portrait of the actor dressed as the dashing D'Artagnan of *The Three Musketeers*. A number of entrepreneurs in the oil business gained an affection for Charlie and his art, ultimately sharing some of their fortunes with the Russell family.

Among the many engaging people they met in California, Charles Lummis was perhaps the most kindred spirit. He had come west from Cincinnati and established himself as a newspaperman and student of southwestern life. The Navajo Indians were his specialty, and he missed no opportunity to involve anyone who expressed even the slightest interest. Charlie was natural prey, and though he strayed only infrequently from Montana subjects, he now explored themes of the Southwest with some success.

What he liked about Lummis was exactly the same thing he liked about his Montana friend Linderman. They all sought to find personal identification with Indian life and devoted themselves to establishing a spiritual union with native traditions. Though Lummis was an anthropologist, Linderman a folklorist, and Russell a painter, they all harbored the same fantasy—that men could, if properly motivated, return to nature. The easiest means to that end was through a transfer of self to the mode of an Indian. After their first meeting, Charlie wrote to Lummis:

The Salute of the Robe Trade

1920. Oil on canvas, 29½ x 47¼"
The Thomas Gilcrease Institute
of American History and Art
Tulsa, Oklahoma

Even in his late paintings Russell owed a debt to Karl Wimar. The composition of this work and others of the period relies on Wimar's painting Indians Approaching Fort Benton *(1859), which was given to Washington University, in his hometown, Saint Louis, in 1886.*

Fairbanks as D'Artagnan

I have eaten and smoked in your camp and as our wild brothers would. I call you Friend. Time onley changes the out side of things. it scars the rock and snarles the tree but the heart inside is the same. In your youth you loved wild things Time has taken them and given you much you dont want. Your body is here in a highly civilized land but your heart lives on the back trails that are grass grown ore plowed under If the cogs of time would slip back seventy winters you wouldent be long shedding to a brich cloth and moccasens.

This transference of time and culture was Russell's way of dealing with his love of Indian peoples and the paradoxes of his own life in the West. He was gratified to find men who felt similarly, and he shared deeply and genuinely in their mutual reverie.

During the late years of his life Russell expressed that reverie in his art with convincing force. His paintings and writings reflect the nostalgic mood with particular brilliance, and he frequently used these expressions to pay tribute to a past he had himself known only through history books and lore. *The Salute of the Robe Trade*, for example, harks back to an era when Indian and Anglo lived in delicate but harmonious balance, sharing the spoils of a bounteous West. Here a band of Blackfoot traders converges on an American Fur Company fort along the Missouri River, a countryside Russell had known since boyhood. *When White Men Turn Red* echoes the same moods and reflection.

To Russell, his romance was true history and thus valid beyond the work of many of his contemporaries. "You know I get a laugh out of some of these novels and moving pictures," he told a Denver newspaper in 1921. "Cowpunchers and Indians and automobiles all mixed up. Oh, I guess it's all right. You've got to romance a lot to make money these days. If you don't do anything but tell the truth in stories and paintings, it's nothing but plain history and nobody cares anything about buying history except a few old fellows like me." Of course there was a tremendous market for Russell's special brand of history and romance. Nancy sold *The Salute of the Robe Trade* to a wealthy California oilman, William Armstrong, for ten thousand dollars. Such successful merchandising also explains Russell's tolerance of winters in Pasadena.

The appeal of Russell's paintings for men like Armstrong lay in their naturalism and vivid, powerful coloring. Although generally laissez-faire in his attitude toward other artists, Russell abhorred modernism, saying that "it goes over my head" and that most modernist works reminded him of "the feeling of a bad stomach after a duck lunch." He spoke bitterly against the "French School" (the Impressionists), denouncing their open painterliness as deception—a cover-up for poor drawing. His heroes were of the same persuasion—men who resisted the currents of new art and relied staunchly on the self-professed virtues of their traditional modes. His two favorites were the grand-manner landscape painter Thomas Moran and the popular illustrator Maxfield Parrish. By the early 1920s they were both anachronisms.

Russell praised Moran for staying close to nature in his vision. "Lots of folks

Fairbanks as D'Artagnan

1924. Bronze, height 11¼"
Amon Carter Museum
Fort Worth, Texas

The Russells met film star Douglas Fairbanks, Sr., in 1921. They enjoyed the Hollywood crowd, and Nancy particularly relished these glamorous associations.

When White Men Turn Red

1922. Oil on canvas, 24 x 36¼"
Courtesy Sid Richardson Collection
of Western Art
Fort Worth, Texas

Maxfield Parrish's golden hues, reflected in the meandering Missouri River, provided the backdrop for many of Russell's later western scenes. Here it complements the arrival of a new couple at camp, as two cultures bridge a gulf where nature perceives none.

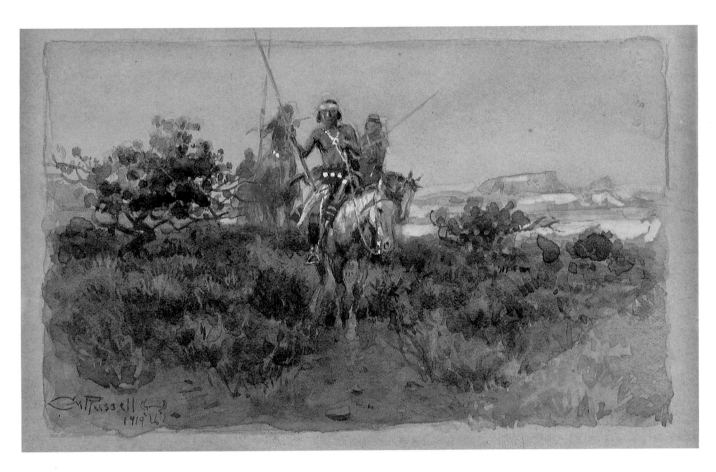

Return of the Navajos

laugh at him now," Charlie mused, but at least the grand old painter could still be revered for retaining an allegiance to naturalism. "When you look at his pictures, the old hills are right there."

Parrish provided lessons in bold color and clarity of presentation. "I've learned a lot from that man," Russell commented in 1921. Parrish had taught him to believe in the vivid colors that suffuse the Montana land and sky and to paint them as he saw them without hesitation. There should be no fear of over-statement. "If you can see color [in nature] you know there's not fine enough color in the tubes to exaggerate them," Charlie concluded.

Thus Russell shared the spirit of American traditions in art with his fellow old-guard painters. As they did, he sought an immediate emotional and visual response rather than the intellectual reaction called for by much of modernist art. Friends such as William Armstrong, in endorsing Russell with their patronage, confirmed the veracity of that artistic mission. On a more practical level, they also provided a welcome infusion of financial support, which meant considerable comfort for the Russells in their later years.

California was not alone in summoning up enthusiastic purchasers for Russell's artwork. The East Coast did its part, with Pittsburgh one of the artist's most lucrative quarters. New York and New Jersey also produced a number of supporters and collectors. Dr. Philip G. Cole of Tarrytown, New York, is reputed to have amassed the largest collection of Russell's art during that period. Born in Montana, he had practiced medicine in Helena before moving east after World War I. He never forgot his roots or the artist who preserved them for him on canvas and in bronze.

Even greater admirers of Russell were the New York stockbroker and his wife Malcolm S. and Helen Raynor Mackay of Tenafly, New Jersey. They met the Russells about the time of Charlie's Folsom Galleries exhibition in 1911 and became immediate fast friends. Malcolm and Charlie would amuse themselves roping calves near the Mackay stables in Tenafly, which would take them both back to Montana. The Mackays held substantial ranching interests southwest of Billings, but Malcolm's investment business kept him from going there as often as he would have liked. So important was the Mackay-Russell relationship that when Malcolm built a new house on the Tenafly property in 1918, he added a special wing that was affectionately dubbed the "Russell Room," which was filled with Russell paintings and western decor. The fireplace, adorned with the artist's monogram and personal Indian symbol, the antelope, was decorated by Russell in 1921. A year later, when he gave Malcolm the painting *Charles M. Russell and His Friends*, the fireplace was modified to accommodate the gift.

The painting portrays Russell as an interlocutor gesturing back to the flat butte country between Great Falls and Cascade. With outstretched arm he introduces his heroes of Montana's frontier past and confidently interjects himself as their interpreter. Despite the sympathetic theme and the grand historical self-portrait, some elements of the painting, especially the muddy colors and unresolved foreground, indicate a partial waning of his technical prowess. In 1923, at

Return of the Navajos

1919. Watercolor, 3½ x 5"
Collection of Mr. and Mrs. S. H. Rosenthal, Jr.

Anthropologist Charles Lummis transmitted to Russell his admiration for the picturesque qualities of southwestern Indian life. But only Russell could so convincingly bring that quiet beauty alive through his art.

*Charles M. Russell and
His Friends*

1922. Oil on canvas, 42 x 81"
Mackay Collection, Montana Historical Society
Helena, Montana

*In this self-portrait, Russell presents him-
self as the historian of Montana's past.
His friends from the cattle days and his he-
roes from tribal legends ride up a ravine
from the valley of the Missouri River.
Square Butte, one of his favorite land-
marks, looms in the distance, capped by the
expansive Montana sky.*

age fifty-nine, he suffered his first serious illness, a bout of sciatic rheumatism,
which left him incapacitated for many months. Nancy also suffered from poor
health and was bedridden from time to time. The next spring he wrote to
Josephine Trigg, the daughter of his close friend and Great Falls neighbor Al-
bert Trigg, "Old Dad Time trades little that men want he has traded me wrin-
kles for teeth[,] stiff legs for limber ones but cards like yours [birthday
greetings from Josephine] tell me he has left me my friends and . . . good friends
make the roughest trail easy."

Although the quality of some late work diminished, there are exceptions.
One is Russell's *Mexican Buffalo Hunters*, which was used to compensate Dr. A. P.
Whittemore of Great Falls for medical bills. It shows Russell's affection for the
warm glow of southwestern light and the pastel distances of the desert landscape.
The timeless elegance of the painting and the deft resolution of all its elements
are evidence that Russell's powers of observation and execution were still intact,
at least occasionally.

Some of his late oils also excel in quality of expression and technical facility.
The *Wolfmen* provides a summary statement of Russell's total dedication to the
theme of the noble true American, basking in an aura of reverential light and set
atop a Montana hill as if mounted on a pedestal. It was not a new tone but a reso-
nant one, worthy of Russell's lofty estimation of Indian peoples.

Late in Russell's life his friend humorist Irving S. Cobb wrote to him, ex-
plaining his thoughts about the artist's contribution to American art. "I want to

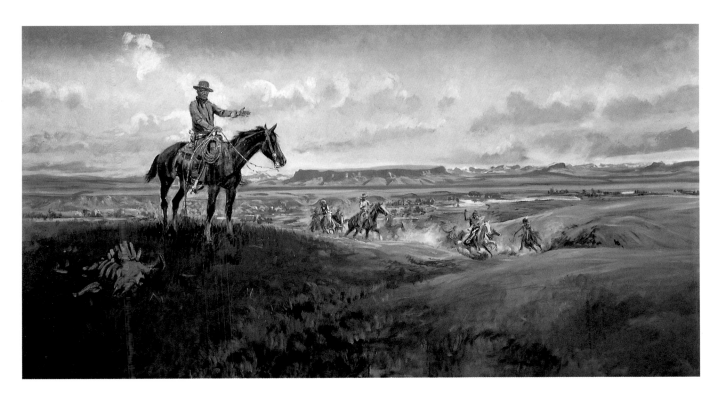

Charles M. Russell and His Friends

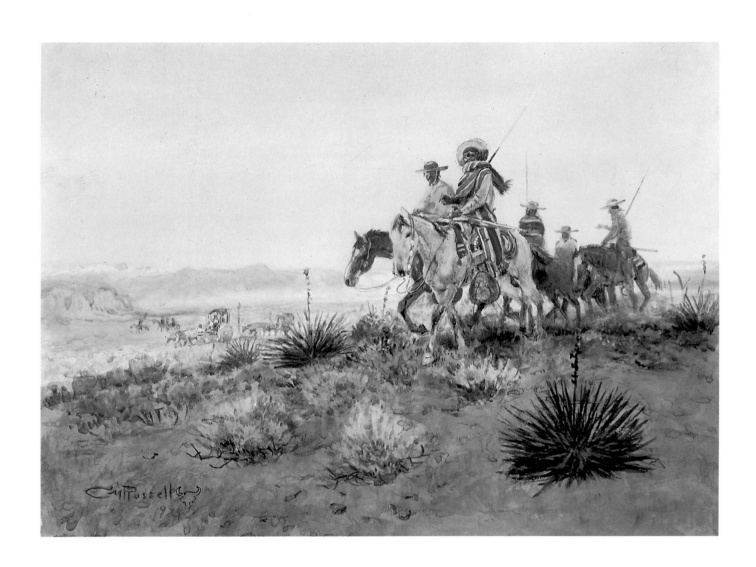

Mexican Buffalo Hunters

1924. Watercolor, 13⅝ x 18½"
Collection of Fred and Ginger Renner

From the 1880s on, Mexico was a subject for Russell's paintings. His work was shown in Mexico City in 1906, and critics proclaimed that the "exquisite touch of his magic brush" was extraordinary. Nearly twenty years later he celebrated the "exquisite touch" of Mexican light in this painting.

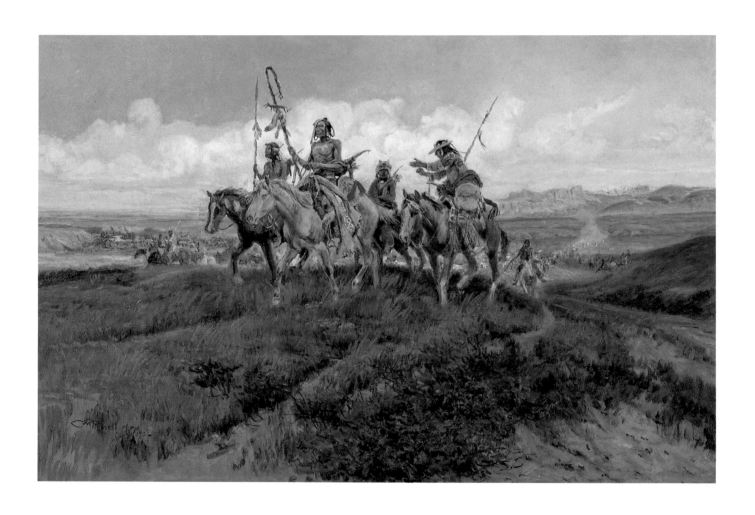

The Wolfmen

1925. Oil on canvas, 24 x 36"
Private collection

Solid compositions make for solid paintings. Russell knew this and used the prescription wisely. Here the "X" formed by crook, spear, trail, and bank establishes a solid basis for the featured group of riders as they surmount the promontory and fill the picture plane.

Illustrated Letter to Dr. Philip G. Cole

September 26, 1926. Pen and ink with watercolor
The Thomas Gilcrease Institute
of American History and Art
Tulsa, Oklahoma

This letter, written shortly before Russell's death, speaks to his lasting reverence for Montana and nature as revealed there. The autumn tranquillity in the vignette and the proud bull elk at the center perhaps suggest Russell's feelings about himself and his life as it draws to a close.

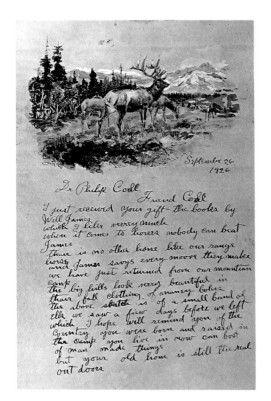

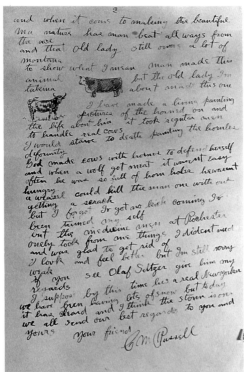

Russell on Neenah
or *On Neenah, Self-Portrait*

Date unknown. Polychrome wax, height 10″
Courtesy of the Buffalo Bill Historical Center
Cody, Wyoming

With hands cupped against the wind, Russell lights a hand-rolled cigarette. Russell's "smoke," like his horse and his attire, was an integral part of his self-image.

tell you what is the truth," Cobb began. "That you can do more with camel's whiskers and earthen pigments out of tubes than any man at present residing in this hemisphere. America owes you a lot for putting on canvas the life of the West that is going fast."

In October, 1926, Russell died in Great Falls. He was mourned by the entire state of Montana, as well as many people from the far corners of the nation. But though he was gone, his imagery and the intensity of his expressive force remained alive. In 1929 Nancy published a volume of Charlie's cherished and charming illustrated letters, titled *Good Medicine*, with an introduction by Will Rogers. He inscribed the first numbered copy (Sam Rosenthal Collection) to her. In that salutation he discussed Russell's writing, but he might have been describing all of his art. "He didn't know he was writing for all the ages did he. He left us Nancy, But he *left us much*."

Russell has also been preserved in the art of many painters and sculptors who followed in his footsteps. They gained influence and inspiration from Russell because he and his art provided the equivalent of a pictorial eulogy for the frontier. He lived that part so wholeheartedly and genuinely that those who followed were simply forced to quote from "the Cowboy Artist's" work if they wished to be part of the picture. The number of followers, many flourishing even today, demonstrates that he was larger by far than his own oeuvre. He had shaped the western myth, provided its standards, and given birth to its popularity. His legacy is America's treasure.

Russell on Neenah or *On Neenah, Self-Portrait*

Chronology

Events in Charles Russell's Life

1864 Born in Oak Hill, Missouri, March 19.

1879 Sent to military school, Burlington College in Burlington, New Jersey.

1880 Goes west to Montana with Wallis (Pike) Miller and works briefly on a sheep ranch.

1881–82 Lives and works with Jake Hoover, hunting and trapping to supply local ranches and mines.

1882–93 Works in various capacities, usually as night wrangler, on Montana cattle operations.

1886 Sends his first important oil, *Breaking Camp*, to St. Louis Exposition and Music Hall Association art show.

1887 Paints *Waiting for a Chinook* and receives local notice. First biographical sketch, "A Diamond in the Rough," published in *Helena Weekly Herald* (May 26); claims sobriquet "the Cowboy Artist."

1890 First anthology of Russell paintings, *Studies of Western Life*, published.

1893 Receives important commissions from William Niedringhaus of Saint Louis. Leaves the range to take up art career full-time. Works shown at World's Columbian Exposition in Chicago.

1896 Marries Nancy Cooper, who soon begins to manage his business affairs.

1897 Some of Russell's stories, accompanied by illustrations, published outside Montana in *Recreation* magazine (April).

1900 Russells move to their permanent home at 1219 Fourth Avenue North, Great Falls, Montana.

1901 Exhibits works in Saint Louis and receives encouraging response as "St. Louis Lion"; compared favorably with Frederic Remington.

1903 Russell's first autobiographical account appears in *Butte Inter Mountain* (January 1). First one-man show at Noonan-Kocian Galleries in Saint Louis. Sends work to World's Fair. Befriends John Marchand and visits New York. Adds log-cabin studio to Great Falls house.

1904 Casts first statuettes in bronze.

1906 Begins to use his summer cabin at Lake McDonald, Bull Head Lodge, as wilderness haven for fellow artists and writers from across the country.

1907	First one-man show in New York.
1911	Major one-man show in New York, "The West that Has Passed," at Folsom Galleries. Wins commission for Lewis and Clark mural at the Montana State House of Representatives.
1914	Exhibition "The West that Has Passed" presented in London, with the Russells in attendance; his work wins international favor.
1916	Russells adopt a son, Jack.
1919	Russell exhibition at Minneapolis Institute of Art. Begins spending part of each winter in southern California.
1921	Sells painting *The Salute of the Robe Trade* for ten thousand dollars.
1923	Russell's health begins to fail.
1925	Granted an honorary Doctor of Laws degree by the University of Montana. Last one-man show during his own lifetime, held at Corcoran Gallery of Art, Washington, D.C.
1926	Commissioned to paint murals in library of E. L. Doheny, Los Angeles, for thirty thousand dollars. Dies in Great Falls on October 24. Nancy moves into Trail's End, a house they were building in Pasadena, and remains until her death in May, 1940.

Photograph Credits

The author and publisher wish to thank the museums, galleries, libraries, and private collectors who permitted the reproduction of works of art in their possession and supplied the necessary photographs. Photographs from other sources (listed by page number) are gratefully acknowledged below.

Courtesy Richard A. Bourne Co., Inc., Hyannis: 38; W.L. Bowers: 97, 143; Buffalo Bill Historical Center, Cody: 22, 46, 67 top; Carl G. Lindquist, Pittsburgh: 118; Linda Lorenz: 24–25, 28, 44, 50, 62–63, 76, 80, 83, 87 left, 88–89, 92, 96, 120–21, 134; Louis Meluso, Sherman Oaks: 71; Gary Mortensen, Minneapolis, 102; Courtesy New York Public Library, New York City: 31, 33, 67 bottom; D. O'Looney: 94; Courtesy Ginger K. Renner: 23 top, 30 left, 32, 48, 58, 65; Clive Russ, Courtesy Vose Galleries of Boston: 13; Bob Schlosser, San Marino: 129 left; John Smart, 111, 141; © 1979 Sotheby's, Inc., New York City: 34.

Bibliography

Related Publications

ADAMS, RAMON F. AND HOMER E. BRITZMAN. *Charles M. Russell: The Cowboy Artist*. Pasadena, Calif., 1948. The first complete and reliable biography.

CLARK, CAROL. *Charles M. Russell*. Fort Worth, Tex., 1983. Brief but refreshing review of works by Russell in the Amon Carter Museum Collection.

DIPPIE, BRIAN W. *Looking at Russell*. Fort Worth, Tex., 1987. A pioneering effort at critical analysis of Russell's art.

————. *"Paper Talk": Charlie Russell's American West*. New York, 1979. Compilation of selected letters, with notes by Dippie.

————. *Remington & Russell*. Austin, Tex., 1982. An important comparison of the two artists, with catalogue of the collections of the Sid W. Richardson Foundation.

LINDERMAN, FRANK BIRD. *Recollections of Charley Russell*. Edited by H. G. Merriam. Norman, Okla., 1963.

McCRACKEN, HAROLD. *The Charles M. Russell Book*. Garden City, N.Y., 1957.

RENNER, FREDERIC G. *Charles M. Russell (1864–1926): Paintings, Drawings and Sculpture in the Collection of the R. W. Norton Art Gallery*. Shreveport, La., 1979. A comprehensive analysis and biography, with specific catalogue references to the Norton Collection.

————. *Charles M. Russell: Paintings, Drawings, and Sculpture in the Amon G. Carter Collection*. Austin, 1966. Excellent biography and descriptive catalogue of one of the nation's largest Russell collections.

————. *Paper Talk: Illustrated Letters of Charles M. Russell*. Fort Worth, 1962. Compilation of selected letters, with notes by Renner.

RENNER, GINGER. *A Limitless Sky: The Work of Charles M. Russell.*, Flagstaff, Ariz., 1986. Fresh and insightful essay on Russell and his patrons, with a catalogue of his works in the Rockwell Museum Collection.

RUSSELL, AUSTIN. *Charles M. Russell: Cowboy Artist*. New York, 1957. A readable and anecdotal account of Russell's life by his nephew.

YOST, KARL AND FREDERIC G. RENNER. *A Bibliography of the Published Works of Charles M. Russell*. Lincoln, Nebr., 1971. The definitive bibliographic reference.

Earlier and Unpublished Works

CONWAY, DAN R. *A Child of the Frontier.* An unpublished biography commissioned by Nancy Russell.

NOYES, AL J. *In the Land of Chinook or the Story of Blaine County.* Helena, Mont., 1917.

PRICE, CON. *Trails I Rode.* Pasadena, Calif., 1947.

RANKIN, JAMES BROWNLEE. *The James Brownlee Rankin Collection of Letters and Other Papers Pertaining to Charles M. Russell.* An unpublished volume of research letters and documents collected by Rankin.

RUSSELL, CHARLES M. *Good Medicine: Memories of the Real West.* Garden City, N.Y., 1929. Nancy Russell's initial compilation of her husband's letters, with a provocative introduction by Will Rogers.

————. *Trails Plowed Under.* Garden City, N.Y., 1927. An anthology of Russell's writings published shortly after his death.

Important Articles

AUSTIN, JAMES G., "Charles M. Russell: Literary Humorist," *MidAmerica* XII (1985).

DIPPIE, BRIAN W. "Charlie Russell's Lost West," *American Heritage* XXIV (April, 1973): 4–21. 89.

ROEDER, RICHARD B., et. al. *Montana: The Magazine of Western History* (Summer, 1984). Issue is dedicated exclusively to Russell.

RUSSELL, CHARLES M. et al. In *Persimmon Hill* XI (Summer/Fall, 1982). Entire issue devoted to Russell, his life and art, with an especially useful article by Joe DeYong titled "Charlie and Me."

SILLIMAN, LEE. "The Cowboy on Canvas...," *Montana: The Magazine of Western History* XXI (Winter, 1971).

TOOLE, K. ROSS et al. *Montana: The Magazine of Western History* VII (October, 1958). This issue is dedicated exclusively to Russell.

Exhibition Catalogues

Charles M. Russell: American Artist. Museum of Westward Expansion, Gateway Arch, Saint Louis, Mo., 1982. Important retrospective exhibition, with valuable essays by Janice K. Broderick, Brian W. Dippie, and Robert Archibald.

Charles M. Russell: The Frederic G. Renner Collection. Phoenix Art Museum, Ariz., 1981.

C. M. Russell: The Mackay Collection. Montana Historical Society, Helena, Mont., 1979.

The Log Cabin Studio of Charles M. Russell. The Russell Memorial Committee, Great Falls, Mont., n.d.

General Sources

EWERS, JOHN C. *Artists of the Old West.* Garden City, N.Y., 1965.

GOETZMANN, WILLIAM H. AND WILLIAM N. GOETZMANN. *The West of the Imagination.* New York, 1986.

HASSRICK, PETER H. *The Way West: Art of Frontier America.* New York, 1977.

Index

Page numbers in *italics* refer to illustrations.